Newark Museum

SELECTED WORKS

Scala Publishers in association with the Newark Museum

This book has been published in conjunction with the Newark Museum's Centennial Year 2009. It has been made possible through the generous support of:

NEW JERSEY COUNCIL FOR THE HUMANITIES

Newark Museum Volunteer Organization

First published in 2009 by
Scala Publishers Ltd
Northburgh House
10 Northburgh Street
London EC1V 0AT, UK
scalapublishers.com

In association with

49 Washington Street
Newark, New Jersey 07102-3176
newarkmuseum.org

ISBN 978-1-85759-588-8

Project Director and Editor: Beth Venn
Designer: Pooja Bakri
Project Manager for Scala: Kate Norment
Photo Editor: Olivia Arnone
Printed in Singapore

10 9 8 7 6 5 4 3 2 1

Dimensions are listed as height x width x depth.
For vessels, dimensions are listed as height x diameter at widest point.

Cover: Joseph Stella. *The Voice of the City of New York Interpreted*, 1920–22 (detail). See pages 28–29.

The Newark Museum, a not-for-profit museum of art, science and education, receives operating support from the City of Newark, the State of New Jersey, the New Jersey State Council on the Arts/Department of State— a partner agency of the National Endowment for the Arts, the New Jersey Cultural Trust, the Prudential Foundation, the Geraldine R. Dodge Foundation, the Victoria Foundation, the Wallace Foundation, and other corporations, foundations and individuals. Funds for acquisitions and activities other than operations are provided by members and other contributors.

Contents

Foreword 4

Acknowledgments 5

A Museum and Its City 6

American Art **12**

Arts of the Americas **44**

Arts of Africa **56**

Arts of Asia **80**

Decorative Arts **108**

Ancient Art **136**

Beyond the Galleries **148**

Education at the Newark Museum, Victoria Hall of
Science, Alice and Leonard Dreyfuss Planetarium,
Mini Zoo, Educational Loan Collection, Alice Ransom
Dreyfuss Memorial Garden, Newark Fire Museum,
Old Stone Schoolhouse, Ballantine House

Trustees and Museum Council 166

Photography and Copyright Credits 167

Contributing Authors and Funding Partners 168

Foreword

Quantifying one hundred years in the life of a museum, one hundred years of collecting and educating, one hundred years of partnerships within our city and beyond, has been a happy challenge for all who have participated in preparing this book.

Clearly we have not exhausted our subject, the path-breaking institution begun so long ago by John Cotton Dana. This book alone cannot begin to convey the breadth and depth of the collections. It is our hope that it will serve as more than simply an introduction to nearly one hundred and fifty of the Museum's most treasured objects, and that it might also reveal a good deal about the wealth of ideas and artistic expression the works represent. More of course than a collection of great objects, the Newark Museum has, since its founding, been an institution of ideas. Dana's conviction that a museum would be of value only if it were of use was a tenet upheld by the founding trustees, among them, of course, Louis Bamberger, who funded our first building. Generations of loyal and supportive trustees have followed the founding thirty, and to those civic stewards we remain ever grateful. Now the largest museum in New Jersey, the Newark Museum is housed on a campus of seven buildings in the heart of one of America's oldest cities.

Countless curators, educators and specialists, in every conceivable field from engineering and human resources to conservation, information technology, animal welfare and visitor services, have devoted their professional lives to the Newark Museum. Common to these men and women has been a calling to the Museum as a vocation worthy of their intelligence, ingenuity and perspicacity. No one can sufficiently sum up their accomplishments.

And to the Museum's partners, beginning with our founding partner, the City of Newark, and now an ever-radiating circle, the trustees, staff and I express our great and humble appreciation. The support you have provided has profoundly affected the lives of millions of schoolchildren and adults.

We are proud that this museum has embraced the richness of world cultures while making education, access and civic service central to its mission. A century after its founding, the Museum is now custodian to over 200,000 objects in the departments of American Art, Arts of Asia, Arts of the Americas, Arts of Africa, Decorative Arts, Ancient Art, Numismatics and the Natural Sciences. The Museum is renowned for its thoughtful approach to collecting and presentation, for connecting objects in its collections to the cultural needs of its communities, for producing interdisciplinary projects in the humanities and sciences and for making important connections across traditional collecting areas.

The understanding of any object, no matter how extraordinary, can be greatly enriched by seeing it in relation to other objects. After each chapter in this book, we have taken the opportunity to highlight our interdisciplinary approach by presenting "interludes," selections of objects that, together, inform the meaning of each. And while the collections lie at the heart of our mission, a museum is always greater than the sum of its objects. I hope that the "Beyond the Galleries" section of this book will help illuminate much about this institution's life, its unique history and innovative programming.

I again recognize the invaluable support of the Museum's Board of Trustees and major funding partners for all the dimensions of the Museum's work that this book represents. I take this opportunity as well to thank project director Beth Venn and her team for making this book the important contribution it is, both to the history of this museum and to the museum community worldwide.

Mary Sue Sweeney Price
Director

Acknowledgments

No single publication within memory has drawn on the talents of so many staff members in so many of the Museum's departments. It is never easy to put one's pressing projects aside to contribute to a larger pan-Museum effort, and so I am especially grateful that each and every staff member with a role to play in this book did just that. The Museum's librarian, William Peniston, and its archivist, Jeffrey Moy, were among the first to engage in this effort as they thoroughly combed through historical documents and photographs and supplied research to many of our authors. William's extensive knowledge of the institution formed the backbone of the history essay in this book.

What makes the Newark Museum—and hence this book—so remarkable is that we have the ability, under one roof, to not only experience the arts of many cultures, but to learn about science from our entomologist, Sule Oygur; space exploration from our astronomer, Kevin Conod; and the care of our living collection from our zookeeper, Kristen Schmid. I am grateful to the contributions that our natural sciences staff members made to this book so that it is a true reflection of the comprehensive nature of our institution. This book would not be complete without the efforts of our education department to illuminate the Museum's many special offerings, from a loan collection to a fire museum to our ongoing public programs. For their work on the "Beyond the Galleries" section, I am indebted to Ted Lind, Deputy Director for Education; Helene Peters, Manager of the Educational Loan Collection; and Lucy Brotman, former Director for Education.

The extensive knowledge of the collections that the Museum's registrars have brought to this project has made it possible to publish information on the objects accurately and completely. Collections Manager Rebecca Buck, along with Registrar Amber Woods Germano and Associate Registrar Antonia Moser, attended to many details concerning the objects shown here. Senior Preparator Jason Wyatt provided curators with essential object information, frequently heading into storage to check on the many details of the objects published here, and providing our outside writers access to the collections. Associate Registrar Olivia Arnone took on the herculean task of securing the nearly two hundred images that appear in this book—overseeing new photography, locating existing photography and securing the necessary rights. Her willingness to take on this critical aspect of the book and her calm and determined demeanor made her a valued collaborator on this project.

The Museum's dedicated curators—Christa Clarke, Holly Pyne Connor, Ulysses Grant Dietz, Mary-Kate O'Hare and Katherine Anne Paul—along with former curators Susan Auth, Valrae Reynolds and Anne Spencer, worked with me on the arduous task of selecting the most significant objects for inclusion, meeting challenging deadlines, thoughtfully and seriously. I appreciate their support of this effort to bring objects from all collecting departments together in one publication for the first time. Curatorial Assistant Millicent Matthews, who supports the curators daily, lent her keen organizational skills and her patience at every stage of putting this book together.

My two closest colleagues on this project have been Alison Edwards, Director of Exhibition Planning and Special Projects, and U. Michael Schumacher, Marketing Communications Manager. Their institutional knowledge, critical thinking and sensitive editing have made this a richer book. Their dedication to this project, along with their humor and constant support, have made them invaluable partners. Finally, I am grateful to our director, Mary Sue Sweeney Price, for making this project possible and for all she has done to guide and to nurture this publication. Her deep understanding of and longstanding commitment to this museum are evident throughout these pages.

Beth Venn
Curator of Modern and Contemporary Art
and Senior Curator, Department of American Art

A Museum and Its City

In the autumn of 1929 the museum founded by John Cotton Dana (1856–1929) had just marked its twentieth anniversary and was settled into its sleek new building, designed by Chicago architect Jarvis Hunt and funded by Newark department store owner Louis Bamberger. The new building, opened to the public in 1926, was not "a temple in a park," as were most large city museums, but a welcoming, useful museum in the heart of a thriving downtown. Dana and Bamberger wanted to bring good design and cultural literacy to a wide audience. Their partnership resulted in a building full of light, organized to attract "ordinary" people—the thousands of Newark's office workers, factory workers and children—who were not necessarily museumgoers. The Newark Museum in 1929 was the opposite of every other major museum in America's industrial cities, and that was no accident.

The Newark Museum began as two large skylit exhibition spaces, one devoted to art, the other to science, on the fourth floor of the Newark Free Public Library. These spaces were in place when Dana, one of the most revered librarians of his day, arrived to take over the library's grand new Renaissance palazzo on Newark's Washington Park. Dana immediately began to expand the library's operations beyond the traditional domain of books, pamphlets and periodicals. In 1902 he began to organize annual displays of paintings and sculpture; and as early as 1904, his friend Dr. William S. Disbrow, a physician and collector, designed exhibitions of rocks, minerals, botanical and zoological specimens.

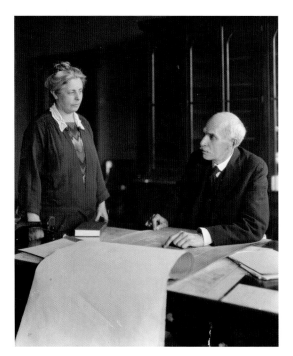

Beatrice Winser with John Cotton Dana, circa 1924, reviewing plans for the new museum building.

Since its incorporation on April 29, 1909, the Museum has assembled some of the most important and highly regarded art collections in the nation; it has for over a century exhibited and collected specimens of rocks and minerals, plants and animals to illustrate the natural sciences; and it has designed educational programs that connect objects and ideas in ways that are both inspirational and transformative for people of all ages from the diverse communities that form its audience. In Dana's words: "A good museum attracts, entertains, arouses curiosity, leads to questioning, and thus promotes learning."

The contextual presentation of objects from many cultures absorbed Dana and his staff and defined the Museum's early projects. In 1908 Dana convinced Newark pharmacist George T. Rockwell to lend his collection of Japanese art for an exhibition, which was so successful that the Museum founder then persuaded the city to buy the collection for the new institution in 1909. In 1910 the art gallery hosted an exhibition of over 200 pieces of modern American pottery. In 1911 Dana exhibited modern photography, and asked the family of founding trustee Edward N. Crane to donate a collection of Tibetan artifacts in his memory. The following year Dana traveled to Europe to collect objects from craft shops and department stores, while organizing the pioneering exhibition *Modern German Applied Arts*, which

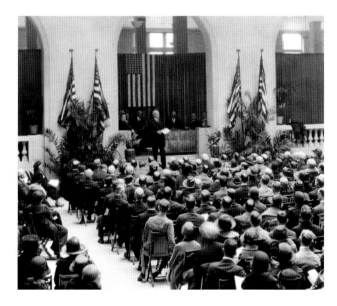

John Cotton Dana speaking at the dedication ceremony for the new museum building, May 14, 1925.

circulated to five midwestern cities and is considered the first exhibition of modern industrial design in the United States. He tirelessly approached scholars and collectors and acquired African, Native American, Latin American, Chinese and Oceanic objects, which he displayed both in the library gallery and in the new museum building over the next fifteen years. During his last visit abroad in the late 1920s he collected North African material in Morocco and Egypt. Although Dana shared the intellectual biases of his day, he firmly believed that art was global and that all cultures produced objects of beauty and utility that could be used to educate and enlighten.

Dana's innovative "process exhibitions" emphasized regional industry and were intended to benefit factory workers and their families. Clay and textiles of New Jersey appeared in 1915 and 1916; the leather and jewelry industries of Newark were highlighted in 1926 and 1929. Even more radical were exhibitions mounted in the last two years of his life, when Dana proclaimed provocatively that "beauty has no relation to price, rarity, or age." Hundreds of

everyday objects of good design—all acquired at local department stores for anywhere from ten cents to one dollar—were displayed in the Museum's marble-floored galleries.

Although he resented the influence that "fine art" had in American museums, Dana believed in supporting American artists, who were ignored by many museums in favor of European artists and "old masters." Having hosted an exhibition of "The Eight" in its founding year, Dana organized one-man shows for Childe Hassam, Max Weber and Stuart Davis. Group shows of modern American artists in the 1910s and 1920s underscored this mission to promote the "art of our time." Dana cultivated Newark's civic leaders to establish a core collection of American painting and sculpture, following his premise that "[a]rt has flourished where it was asked to flourish, and never elsewhere."

Although Dana appreciated the inherent beauty and value of art, applied art and natural science collections (he himself collected Japanese prints and art pottery), he believed above all that a public museum should complement the educational roles of public libraries and public schools. Drawing on learning theories that would not be widely accepted until the late twentieth century, he reasoned that certain people learned through books, while others learned through objects, and therefore modern cities needed both public libraries and public museums of art and science. While his emphasis on the educational value of libraries was typical of Progressive thought of the era, his view of the museum as an educational institution was revolutionary. The Museum established a lending department (today the Educational Loan Collection) to send objects to schools, branch museums and public libraries; and the Junior Museum was founded to serve the region's schoolchildren. Dana also created the Apprenticeship School, the first American program to train museum professionals.

Following Dana's death in 1929, his assistant Beatrice Winser became director, leading the institution during the difficult years of the Great Depression and Second World War. Ambitious exhibitions of modern design in metal, international ceramic art and American folk art were completed before the financial impact of the Stock Market Crash hit. Despite the Depression, Winser continued to build upon Dana's precepts, managing to display real airplanes in the Museum's court and extolling the virtues of chemistry in modern life. The painting and sculpture collections acquired some of their most important modernist icons during these years through trustee support; and in 1938 an exhibition was mounted to celebrate a major gift of Native American art from Amelia Elizabeth White, a pioneer collector from Santa Fe.

Winser asked her staff to develop programs to meet the needs of those with "an excess of enforced leisure," a euphemism for unemployment. In 1930, targeting city children, the Museum began using live animals in the Nature Corner of the Junior Museum, the forerunner of today's Mini Zoo. In 1933 the Museum held workshops for adults in sketching, modeling, nature studies and stamp collecting; today's Arts Workshop was formally established soon after. Musical performances were held in the court of the Museum's 1926 building and in its one-acre garden. Perhaps Winser's most important contribution was the purchase of the neighboring John H. Ballantine House and an adjacent office building in 1937.

Alice Kendall, who had been Winser's assistant, served briefly as director from 1947 to 1949, followed by Katherine Coffey, who had been the curator in charge of exhibitions and programs since 1925. Coffey established separate curatorial departments in the arts and sciences in the early 1950s, hiring a cohort of talented, innovative curators. Although the Museum had collected antiquities previously, the monumental gift in 1950 by New Jersey collector Eugene Schaefer of Egyptian, Greek and Roman objects created a new department. Coffey championed diversity in Museum projects, highlighting the collections and carrying on the tradition of embracing art from all parts of the world. Exhibitions devoted to African art, Buddhist art and Judaic art were mounted alongside educational "dictionary" displays of ceramics, glass and silver. Science exhibits and programs focused on such topics as the geology of New Jersey and the technology of satellites. In 1953 the first planetarium in New Jersey was installed, funded by trustee Leonard Dreyfuss and his wife, Alice.

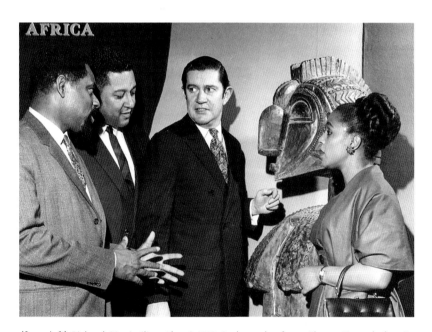

(from left) Richard Maximilian Akwei, U.N. Ambassador from Ghana, Newark deputy mayor Lewis Perkins, Newark Museum director Samuel C. Miller and Mrs. Akwei at the opening of the exhibition *Art of Africa*, January 1969.

In 1967 Coffey hired young art expert Samuel C. Miller from Buffalo's Albright-Knox Art Gallery. He arrived just as Newark was shattered by the cataclysmic riots that would overshadow the city's reputation for the next forty years. Miller, who became director in 1968, helped the sixty-year-old institution not only to survive but to thrive as never before. The staff and trustees responded to their city's crisis by acknowledging the Museum's role in helping to rebuild the city. "Without a vital museum," Miller declared, "the hopes of the city cannot be achieved."

Working with the Museum's strong collections of African and African-American art, Miller reached out to Newark's African-American community, with choreographer and anthropologist Pearl Primus as an advisor. With her collaboration, the major exhibition *Art of Africa* opened in 1969, accompanied by a landmark two-week Festival of Africa. *Jazz in the Garden*, one of the Museum's most enduring summer traditions, was also established in 1969, and was followed in 1976 by the annual *Newark Black Film Festival.*

Miller successfully expanded the collections by working closely with the curators to solicit donations and make major purchases to fill gaps in the holdings. Miller's open-minded love for art in all forms embraced each of the curatorial departments, from jazz-age abstractions to powerful Yoruba sculpture, from Tibetan tangkas to masterpieces of Victorian silver. His sympathy for the nineteenth century saved the 1885 Ballantine House, the first floor of which was restored for the Bicentennial in 1976 as a showcase for the decorative arts.

In 1967 Miller began a collaboration with architect Michael Graves, which led in the early 1980s to the start of the largest museum project in the history of New Jersey. Creating an architecturally cohesive campus that doubled gallery space, added new classrooms for adults and children and provided much-needed public amenities such as the Billy Johnson Auditorium and the café in the Charles Engelhard Court, the project won the American Institute of Architects' Honor Award in 1992.

Director Mary Sue Sweeney Price began her career at the Museum in 1975. Under her leadership the Museum has dramatically increased the depth and quality of its collections and has expanded its engagement with diverse audiences. Overseeing a marked increase in dedicated endowments for purchasing collection objects, Price has, with the support of the trustees' Acquisitions and Collections Committee, encouraged all of her curators to seek out objects that bring national significance to their collecting areas, resulting in the acquisition of more major works during the last decade than in any other time of the Museum's history. She has in particular encouraged the purchase of contemporary works from all around the world, embracing the art of today in all its diversity, including significant acquisitions of photography and new media. Price has championed collaborations between curatorial departments to acquire these new works, which often refuse to fit neatly in inherited museum categories. Responding to the demographic changes in New Jersey's vast population, Price has carried on the Museum's founding mission to be useful to the community, establishing advisory committees for the Latino, Chinese, Ghanaian and Indian communities linked to major exhibitions held at the Museum. *Badge of Honor* (1994) involved an installation by artist Pepón Osorio in a Newark storefront followed by an installation at the Museum; *Wrapped in Pride: Ghanaian Kente and African-American Identity* (1999) drew on the experience of local residents as well as the Ghanaian diaspora in New Jersey; *The Bride Wore Red: Chinese Wedding Traditions* (2005) compared wedding traditions before and after immigration from China; and *Cooking for the Gods: The Art of Home Ritual in Bengal* (1995) explored the transference of Bengali rituals to suburban America.

In 2001, under Price's leadership, the reinstallation of the American art galleries, *Picturing America,* pioneered a radical new approach to understanding American art as the story of the nation seen through the eyes of its artists. The completion of the Ballantine House restoration in 1994 included a dramatic new interpretation of the decorative arts collections in *House & Home,* an interactive presentation linking objects to the evolving concept of "home" that remains unique in any American art museum. The Junior Museum continues to mount child-focused interactive exhibitions in its own gallery, drawn from the global span of the Museum collections. After two decades of planning, the Victoria Hall of Science opened in 2002, an interactive, specimen-rich learning environment that supports the state's natural science curriculum.

Director Price and her staff have generated support from national, regional and local philanthropy, which complements the ongoing historic operating and capital support that the Museum receives from the City of Newark and the State of New Jersey. This represents civic generosity at its best, underscoring the bond between the Museum and its loyal visitors.

Today the Newark Museum celebrating its 100th anniversary is a far larger, more complex institution than its founders envisioned. Nonetheless, its trustees, director and staff continue to build upon the Museum's historic commitment to outstanding collections, innovative exhibitions and dynamic educational programs. It remains the very model of the *new museum* that was imagined at its inception: a museum dedicated to objects and to the ideas embodied by them.

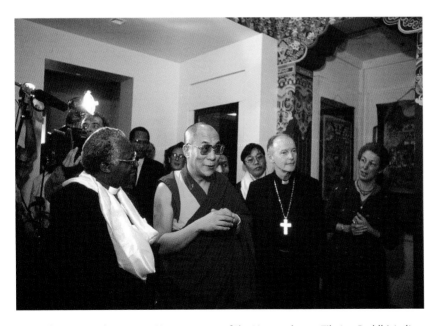

The Dalai Lama at the consecration ceremony of the Museum's new Tibetan Buddhist altar, greeted by (from left) Desmond M. Tutu, Anglican Archbishop of Cape Town, South Africa; Theodore E. McCarrick, Roman Catholic Archbishop of Newark; and Valrae Reynolds, Curator of Asian Collections, September 1990.

American Art

The American Art collection of the Newark Museum is among the most distinguished in the country. It spans from Colonial times to the present, and includes major works by many of the most significant American artists prior to 1945, as well as important postwar and contemporary artists. In addition to painting and sculpture, the collection encompasses drawings, prints, photography, video and new media.

The collection is renowned for its outstanding nineteenth-century landscape paintings by artists such as Thomas Cole, Frederic Church, Albert Bierstadt and George Inness, and for its eighteenth- and nineteenth-century portraits, including works by John Singleton Copley, Gilbert Stuart, Mary Cassatt and John Singer Sargent. A year after its founding, the Museum purchased its first works by contemporary American artists, establishing its pioneering commitment to collecting and exhibiting the work of its time. In its early years, the Museum built a strong collection of works by the American Impressionists and such early twentieth-century masters as John Sloan, Robert Henri and Max Weber. "Art has always flourished where it is asked to flourish, and never elsewhere," founder John Cotton Dana wrote in 1914, "and if we wish for a renaissance of art in America we must be its students and patrons."

Another core strength is the Museum's early American modernism collection, including works by Edward Hopper, Georgia O'Keeffe, Marsden Hartley, Arthur Dove, Stuart Davis, Charles Sheeler and Alexander Calder and a landmark work by Joseph Stella, the monumental *The Voice of the City of New York Interpreted*. The Museum has one of the most comprehensive holdings of geometric abstraction in the country and the largest repository of WPA prints outside the Library of Congress.

The Newark Museum was the first public institution to mount exhibitions of American folk paintings and sculpture in 1930 and 1931, respectively. Folk art holdings have expanded from that time, from early works by Ammi Phillips and Edward Hicks to recent acquisitions of outsider and self-taught artists, including drawings by Martín Ramírez and Bill Traylor and important holdings of sculpture by William Edmondson and David Butler.

The Museum began its commitment to African-American art in 1929 with the acquisition of Henry Ossawa Tanner's *The Good Shepherd*, and continued with important exhibitions such as the landmark 1944 show *Paintings and Sculpture by Negro Artists*, which featured works by such now well-established artists as Jacob Lawrence, Hale Woodruff and Charles White, all of whom are represented in the collection. The American Art collection also contains significant works by nineteenth- and twentieth-century African-American artists Joshua Johnson, Edmonia Lewis, Robert Duncanson, Romare Bearden, Faith Ringgold, Bob Thompson and Willie Cole, among others.

The Museum boasts a fine selection of mid-century paintings by Mark Rothko, Robert Motherwell, Helen Frankenthaler and others and important sculptures by Andy Warhol, Louise Nevelson and George Segal. The Museum continues to collect the art of its time in all media, including recent acquisitions of work by Martin Puryear, Kiki Smith and Bill Viola.

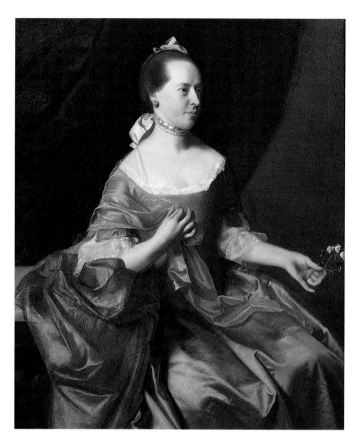

Portrait of Mrs. Joseph Scott,
ca. 1765
John Singleton Copley
(1738–1815; lived and worked in
Boston and London)

Oil on canvas, 50 x 40 in.

Purchase 1948 The Members'
Fund _48.508_

During the eighteenth century, the art of portraiture flourished in America. Patrons wanted a good likeness that expressed family pride and served as a symbol of their wealth and refinement. By the mid-1760s, John Singleton Copley was the most accomplished artist in America. Patronized by both Whig and Tory merchants and professionals in Boston, Copley was renowned for his ability to capture the character of his sitters as well as their material possessions through his brilliant rendering of textures. Like other Colonial painters, he copied and adapted poses and accessories from prints of European court portraits.

Mrs. Scott's husband was a merchant and an active Loyalist who sold supplies to the British troops garrisoned in the Boston area on the eve of the Revolutionary War. Copley portrays Mrs. Scott gracefully posed and fashionably attired in a beautiful rose-colored dress called a _sac_, made from expensive imported fabric that emphasizes her husband's affluence. Wearing an exquisite moonstone choker that Copley employed to augment her lavish appearance, Mrs. Scott holds flowers, a traditional symbol of female beauty, fragility and fertility.

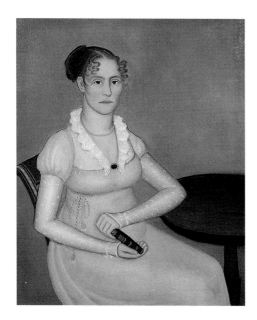

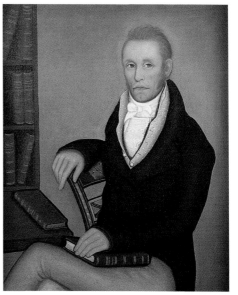

***Mrs. Crane*, ca. 1814–19**
Ammi Phillips (1788–1865; lived and
worked in New York, Connecticut and
Massachusetts)

Oil on canvas, 38 ¾ x 32 in.

Gift of the estate of Alice M. Kaplan, 2001
2001.69.2

***Dr. Crane*, ca. 1814–19**
Ammi Phillips (1788–1865; lived and
worked in New York, Connecticut and
Massachusetts)

Oil on canvas, 39 x 32 in.

Gift of the estate of Alice M. Kaplan, 2001
2001.69.1

Ammi Phillips, who specialized in portraiture, is now acclaimed as one of the most
talented folk artists of the nineteenth century. After his death his reputation fell into
obscurity, and until the 1960s many of his works were attributed to two unknown
painters, "the Kent Limner" and "the Border Limner." These names refer to the fact
that a large number of Phillips' sitters were from the area of Kent, Connecticut, and
the towns along the New York and Massachusetts border. Like other itinerant country
artists, Phillips traveled extensively in search of commissions.

This pair of portraits is from Phillips' Border period, when he employed an
exquisite warm palette. Each has the same painted country chair, is the same size and
shows the sitters in poses mirroring each other. Husband and wife, however, have dif-
ferent settings and accessories that refer to their separate spheres. Dr. Crane appears
in his library surrounded by medical treatises, underscoring his professional activities.
Mrs. Crane's physical beauty and fashionable clothing are emphasized. Holding a
small volume, she indulges in light reading while her husband studies weighty tomes.

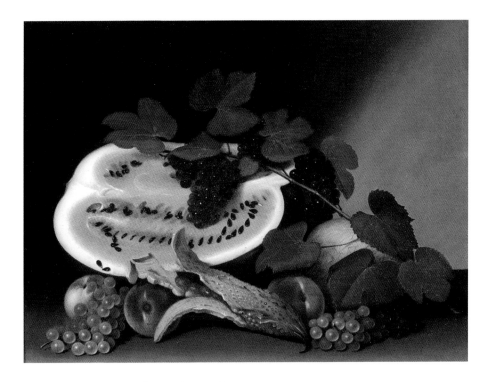

Still Life with Watermelon and Fruit, **1822**
Raphaelle Peale (1774–1825; lived and worked
in Philadelphia)

Oil on canvas, 22¼ x 26¼ in.

Purchase 1960 The Members' Fund *60.581*

The birth of American still-life painting in the 1820s is associated with the city of Philadelphia and with the family of the celebrated artist Charles Willson Peale. Raphaelle Peale, the eldest surviving son of Charles Willson, was the first American painter to specialize in pictures of humble subjects such as fruits and vegetables. Hung in dining rooms during the nineteenth century, these works alluded to the pleasures of eating and drinking as well as the bounty of nature.

In this painting, Peale emphasizes the lushness of the watermelon by showing the fruit cut in half, exposing large areas of dark pink flesh. The profusion of life-size fruits painted in vivid pinks, oranges and yellows and piled on top of each other creates a feeling of abundance and vitality. The work may also celebrate nature's healing power and fertility. The long, gourd-shaped balsam apple was used for healing wounds, while the profusion of seeds in both the balsam apple and watermelon suggest rejuvenation.

The Arch of Nero, 1846
Thomas Cole (1801–1848; lived and worked in New York City and Catskill, New York)

Oil on canvas, 60 ¼ x 48 ¼ in.

Purchase 1957 Sophronia Anderson Bequest Fund 57.24

Thomas Cole is recognized as the founder of America's first true landscape movement, the Hudson River School, examples of which are one of the core strengths of the Newark Museum's collection. While Cole became famous for his paintings of the wilderness and other uniquely American views, he also produced landscapes that referenced grand historical, allegorical and religious themes intended to educate viewers.

On his two trips to Europe, Cole became fascinated with ruins, a subject that Americans associated with the civilized, European landscape. While in Italy in 1832, he sketched the Arch of Nero, part of the Claudian aqueduct located near Tivoli. These graphite sketches provided inspiration for this painting, which combines a huge rendering of the arch with pastoral vignettes of peasants and animals. While the ruined arch alludes to the former glories of the Roman civilization, it was also seen as a symbol of decadence. For Cole's audience, the peasants would have evoked conflicting interpretations as well. They enhanced the picturesque qualities of the scene, but they also suggested that Italy was mired in its past.

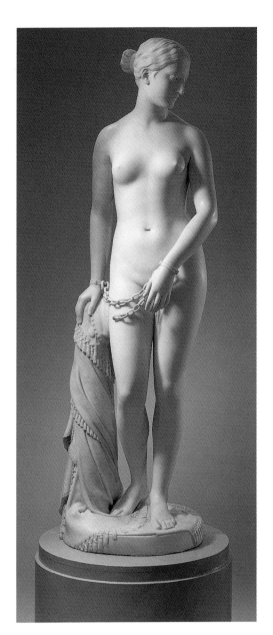

The Greek Slave, 1847
Hiram Powers (1805–1873; lived and worked in Cincinnati, Ohio, and Florence, Italy)

Marble, 65 ½ x 19 x 19 in.

Gift of Franklin Murphy, Jr., 1926 *26.2755*

The Greek Slave was the best-known nineteenth-century American sculpture. Hiram Powers produced six full-sized marbles, and Newark's version, the second, was the most widely seen, as it toured ten major eastern and midwestern cities from 1847 to 1849. While the nude female body may have offended some Victorian American audiences, it was nonetheless a powerful attraction. Adding to the titillating features of the statue, Powers created a compelling narrative that told the tragic story of a beautiful Greek Christian woman captured by Muslim Turks during the Greek War of Independence in the 1820s who is about to be sold at a slave market in Constantinople. By the early 1850s, however, *The Greek Slave* took on additional meaning. Abolitionists interpreted the piece as the first antislavery document in marble and associated it with slavery in the South where blacks were still sold at auctions.

The finest neoclassical sculptor of his generation, Powers resided in Florence, Italy, where he studied classical sculptures, which provided the inspiration for *The Greek Slave* and his other idealized figures.

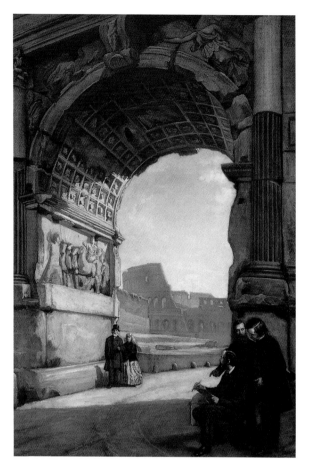

The Arch of Titus, 1871
George Peter Alexander Healy
(1813–1894; lived and worked in Paris)
Frederic Edwin Church (1826–1900;
lived and worked in New York City and
Hudson, New York)
Jervis McEntee (1828–1891; lived and
worked in New York City and Rondout,
New York)

Oil on canvas, 84 x 59 in.

Bequest of J. Ackerman Coles, 1926
26.1260

After the Civil War, American artists became increasingly cosmopolitan, traveling to
Europe for extended periods where they had the opportunity to study the great art of the
past. This work depicts two of the most well-known and dramatic monuments in Rome,
the Arch of Titus and the Colosseum, with the three artists who collaborated on the work
shown in the foreground. Healy, who painted the portraits, places himself in the center
of the group beside Church, who is seated, and McEntee, who holds a large volume.
Standing under the arch is the famous writer Henry Wadsworth Longfellow and his
daughter, Emily. Although collaborations of this kind were common in European art, they
were unprecedented in American painting; the work is further distinguished by its huge
scale. Transcending the personal friendships of the individuals portrayed, this monumental
history painting celebrates and memorializes the camaraderie of American artists and
writers in Italy.

 The Arch of Titus was given to the Museum in 1926 as a bequest from Jonathan
Ackerman Coles, whose outstanding collection became the cornerstone of the Museum's
distinguished holdings of nineteenth-century American art.

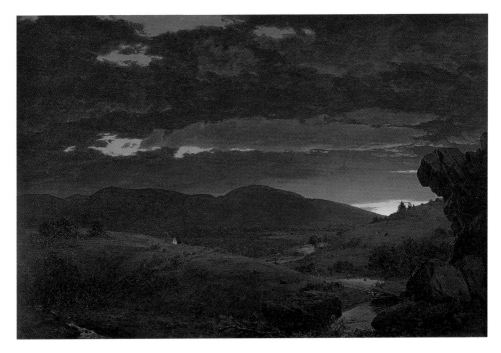

Twilight, "Short Arbiter 'Twixt Day and Night," 1850
Frederic Edwin Church (1826–1900; lived and worked in
New York City and Hudson, New York)

Oil on canvas, 32¼ x 48 in.

Purchase 1956 Wallace M. Scudder Bequest Fund *56.43*

The preeminent landscape painter of the mid-nineteenth century, Frederic Church
created huge compositions combining closely observed details from nature with
fully realized atmospheric effects. The only official pupil of Thomas Cole, Church
was just twenty-four when he painted *Twilight, "Short Arbiter 'Twixt Day and
Night,"* a work that demonstrates his remarkable talent at combining realism and
allegory in a single landscape. While the painting accurately portrays the Vermont
scenery that Church sketched in the summers of 1848 and 1849, it also references
national and literary themes.

In this work, one of Church's earliest sunset scenes, the dramatic, ominous sky
indicates an impending storm, a recognized symbol of social turmoil in the paint-
ings and sermons of the period. The mood of foreboding is augmented by the title
of the painting, a line from John Milton's *Paradise Lost*, at a point in the narrative
when Satan is about to descend to earth wreaking havoc and destruction. At a
time when many feared that the nation was heading irrevocably toward civil war,
Church suggests that the American paradise is indeed threatened.

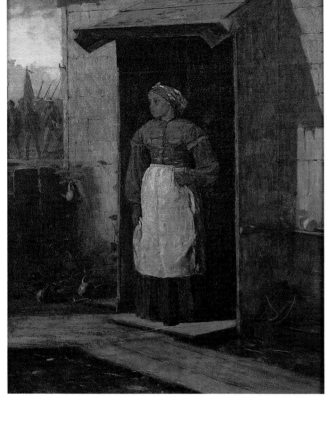

Near Andersonville, 1865–66
Winslow Homer (1836–1910; lived and worked in New York City and Prout's Neck, Maine)

Oil on canvas, 23 x 18 in.

Gift of Mrs. Hannah Corbin Carter; Horace K. Corbin, Jr.; Robert S. Corbin; William D. Corbin; and Mrs. Clementine Corbin Day in memory of their parents, Hannah Stockton Corbin and Horace Kellogg Corbin, 1966 *66.354*

Winslow Homer's Civil War paintings, produced from 1862 to 1871, are often searing social commentaries on national issues of his time. As a young, talented illustrator, Homer was sent by *Harper's Weekly* to cover the war in the fall of 1861, an experience that exposed him to the horrors of combat and the boredom of military life. In his illustrations and paintings of the war, Homer examined the psychological trauma endured by soldiers, rather than focusing on the heroism of battle, a theme historically celebrated by artists.

Here Homer depicts a black woman standing in a doorway, symbolically emerging from the darkness of slavery into the light of freedom. She represents African Americans poised at a critical and transitional period immediately after the war and at the beginning of Reconstruction. Her liberation is in contrast to the uncertain fate of the two captive Union soldiers being taken to Andersonville, the infamous Confederate prisoner-of-war camp in southwest Georgia, where almost thirteen thousand soldiers died from starvation and poor sanitation.

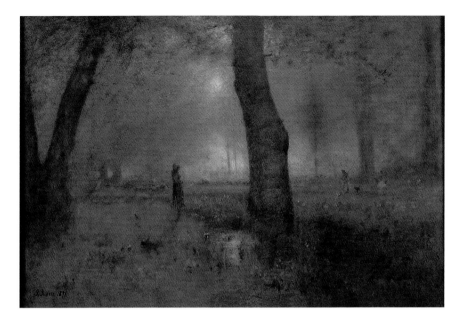

The Trout Brook, 1891
George Inness (1825–1894; lived and
worked in New York City and Montclair,
New Jersey)

Oil on canvas, 30⅛ x 45½ in.

Purchase 1965 The Members' Fund *65.36*

By the mid-1880s, George Inness was acclaimed as America's foremost landscape painter. Rejecting the recognizable subjects and realistic style of the Hudson River School, he created personal and poetic landscapes that were meant to awaken an emotion in the viewer. While grounded in the countryside around Montclair, New Jersey, where he settled in 1885, his late works became increasingly visionary and abstract as Inness suggested nature rather than portraying it literally.

Inness embraced the ideas of Emanuel Swedenborg, the eighteenth-century Swedish mystic and theologian who believed in the interpenetration of the material and spiritual worlds. To expresses these ideas in *The Trout Brook*, Inness created a soft, glowing light that unites sky and water and dissolves the solid forms of the figures and landscape so that they appear to fuse with the heavy atmosphere. The radiant light permeating the scene suggests a spiritual presence in nature, while the balanced composition and the harmonious palette produce a mood of tranquility. Through his use of distinctive, visible and energized brushstrokes, Inness asserts his participation in the creation of this work of art.

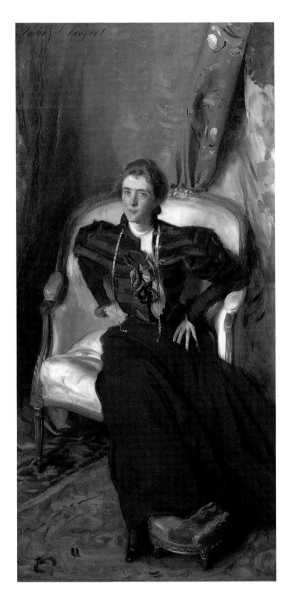

Mrs. Charles Thursby, 1897–98
John Singer Sargent (1856–1925; lived and worked in Paris and London)

Oil on canvas, 78 ¼ x 39 ½ in.

Purchase by exchange, 1985—Gift of Mr. and Mrs. J. Duncan Pitney, Emilie Coles (from the J. Ackerman Coles Collection), Mrs. Lewis B. Ballantyne, Mrs. Owen Winston and the Bequest of Louis Bamberger 85.45

Alice Brisbane Thursby is portrayed as a New Woman of the late nineteenth century, one of a growing number who sought increased freedom in their personal and professional lives. John Singer Sargent captured the sitter's confidence and energy through her aggressive, bold pose, her penetrating gaze and her distinguished forehead, at the time seen as a sign of intelligence. Like Sargent, Mrs. Thursby was a cosmopolitan expatriate living in London.

Although Sargent surrounded the sitter with the trappings of wealth and refinement in the tradition of grand manner portraits, his interpretation was unconventional, even radical, during a period when most women were shown as passive and demure. His remarkable talent for creating a psychological interpretation that captures the essence of the sitter's personality together with his distinctive style of visible, elongated brushstrokes is evident in this masterwork. At the turn of the twentieth century, Sargent was critically acclaimed for his prestigious public and private commissions, which cemented his international reputation as one of the foremost portrait artists of his day.

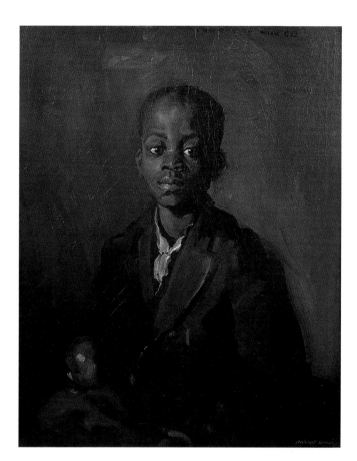

***Portrait of Willie Gee**, 1904*
Robert Henri (1869–1929; lived
and worked in Paris, Philadelphia
and New York City)

Oil on canvas, 31¼ x 25¼ in.

Anonymous gift, 1925 *25.111*

Robert Henri was the leader of a group of urban realist artists who found inspira-
tion in the streets of New York City. These artists, known as the Ashcan School,
specialized in painting the immigrants and migrants who were dramatically changing
the complexion of the city in the early twentieth century. Of particular interest to
Henri were the children he encountered. As he explained, "I would rather see a
wonderful little child than the Grand Canyon." This sympathy and respect for
children is reflected in Henri's portrait of Willie Gee.

Gee was a newspaper boy who delivered Henri's paper at the Sherwood
Studio at Sixth Avenue and 57th Street. Gee and his mother, formerly a slave, had
recently moved to New York from Virginia, settling in the African-American
neighborhood located further west on 57th Street. Henri shows Gee holding an
apple, perhaps a reference to the fruit given out to underprivileged children by aid
organizations. Gee is nobly positioned against a dark background, and his intelli-
gence is underscored by his prominent forehead and large, thoughtful eyes.

The Sheridan Theatre, 1937
Edward Hopper (1882–1967; lived
and worked in New York City)

Oil on canvas, 17 x 25 in.

Purchase 1940 Felix Fuld Bequest
Fund *40.118*

The dramatic architecture and solitary figures that inhabit *The Sheridan Theatre* are subjects that fascinated Edward Hopper from the start of his career. For Hopper, the choice of a movie theater as a subject, and the Sheridan Theatre in particular, was a personal one. Located in New York City's Greenwich Village, just blocks from Hopper's apartment, the Sheridan epitomized the luxurious movie palaces of the 1930s, which arose to satisfy the millions of people who attended the movies every week.

An avid moviegoer himself, Hopper is reported to have declared: "When I don't feel in the mood for painting I go to the movies for a week or more. I go on a regular movie binge!" Although the isolated figures in this painting have been described as lonely and alienated, Hopper himself thought such an interpretation was "overdone." Rather, he seemed to find the shadowy darkness of a movie theater a revitalizing reprieve from the social demands of life in the crowded metropolis.

Abstraction #3, 1910–11
Arthur Dove (1880–1946; lived and worked in upstate New York and Long Island, New York)

Oil on board, 9 x 10 ¹/₂ in.

Gift of Henry H. Ploch, 2000
2000.19.1

Arthur Dove was a rugged individualist whose paintings represent the unseen rhythms and energies of nature. In 1910, the year he first exhibited at Alfred Stieglitz's 291 gallery in New York City, Dove produced a group of what are believed to be the first purely abstract paintings, experiments—or "extractions" as he called them—in organic forms and colors. *Abstraction #3* is among this suite of five pioneering works.

Although abstract, this painting evokes a hilly landscape. The surging diagonals and repeating, radiating forms suggest forces of growth and decay in nature. Dove's good friend Georgia O'Keeffe praised him for being "the only American painter who is of the earth." Along with important works by O'Keeffe, Marsden Hartley, John Marin and other artists known collectively as the Stieglitz circle, *Abstraction #3* represents a particular strength in the museum's early American modernist collection.

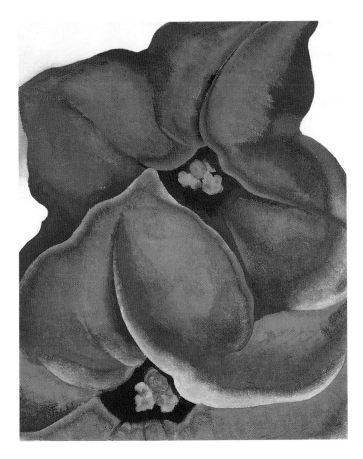

Purple Petunias, 1925
Georgia O'Keeffe (1887–1986;
lived and worked in New York
City and Abiquiu, New Mexico)

Oil on canvas, 15 ⅞ x 13 in.

Bequest of Cora Louise Hartshorn
1958 *58.167*

"Nobody sees a flower, really, it is so small," explained Georgia O'Keeffe.
"So I said to myself – I'll paint what I see – what the flower is to me but
I'll paint it big and they will be surprised into taking time to look at it – I
will make even busy New Yorkers take time to see what I see of flowers."

Throughout her seventy-year career, O'Keeffe united a modernist sensi-
bility with a keen eye to the realism of her environment. In paintings like
Purple Petunias, O'Keeffe explored cropped, close-up views of flowers and
leaves in a magnified scale with an extremely shallow depth of field. This
allowed her to eliminate extraneous details, flatten space and simplify com-
positions to their essence, all the while carefully observing the colors, shapes
and light found in nature. Using bold and saturated shades of blue and vio-
let in *Purple Petunias,* O'Keeffe suggests that the edges of the canvas cannot
contain the expansiveness of the flowers' blossoms.

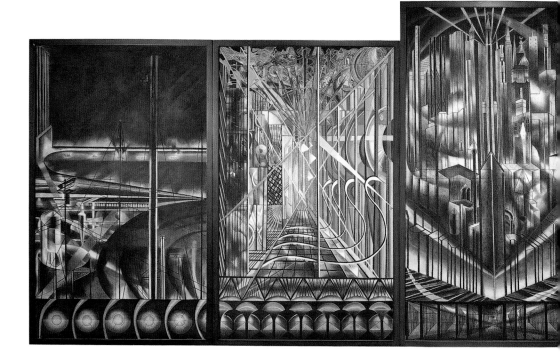

In the opening decades of the twentieth century, New York stood as the grandest expression of the country's technological and financial world dominance. Joseph Stella's monumental painting *The Voice of the City of New York Interpreted*, a panoramic, five-paneled view of 1920s Manhattan, evokes the dizzying dynamism and awe-inspiring spectacle of the city. Measuring over twenty-two feet long, *The Voice of the City* presents key New York landmarks at night, starting on the west side with the Battery, then moving to the middle of the island with Broadway and the skyscrapers, and ending in the east with the Brooklyn Bridge. Below are tunnels for trains, electricity and plumbing.

Stella, who immigrated to New York in 1896 from a small town in southern Italy, interpreted American technology in religious terms, conveyed in this work by the altarpiece format and deep, saturated colors that give the appearance of stained glass windows. Describing a walk across the Brooklyn Bridge, Stella declared: "I felt deeply moved, as if on the threshold of a new religion or in the presence of a new divinity." Purchased in 1937 from Stella's Newark-based gallery, Rabin and Krueger, *The Voice of the City* reflects the Museum's commitment, dating from its founding, to collecting the work of living artists.

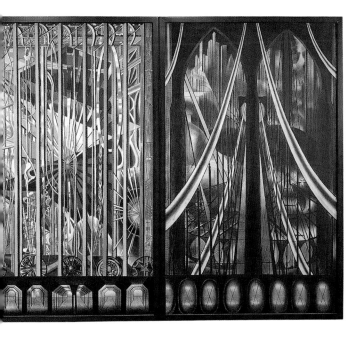

The Voice of the City of New York Interpreted, 1920–22
Joseph Stella (1877–1946; lived and worked in New York City and Europe)

Oil and tempera on canvas, 99 3/4 x 270 in.

Purchase 1937 Thomas L. Raymond Bequest Fund *37.288a–e*

Airport Structure, 1932
Theodore Roszak (1907–1981; lived and worked in Chicago and New York City)

Copper, aluminum, steel, brass, 19 1/8 x 7 x 7 in.

Purchase 1977 The Members' Fund *77.23*

Using industrial forms that suggest modern machinery, Theodore Roszak constructed *Airport Structure* the same year he completed a tool-making course. The title Roszak assigned the sculpture conjures up one of the technological wonders of the early twentieth century: aviation. Flight embodied a global view of the world and captured the imaginations of artists and the public alike who optimistically looked at technology as a form of progress.

For artists like Roszak, the modern language of abstraction was a fitting way to express these feelings and new experiences. Making a reference to Aldous Huxley's futuristic novel, he explained: "I was frankly entranced by the prospects of constructivism, ushering not only a pristine world of free and unfettered objectivity, but also holding out the promise of contributing [to] and perhaps even sharing the work of the 'Brave New World.'"

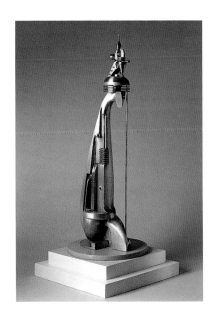

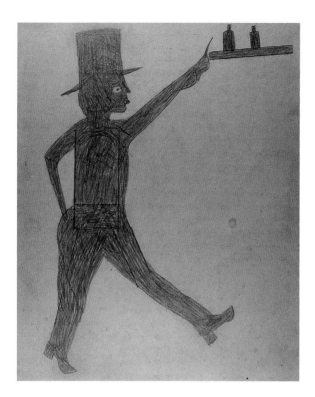

Man Reaching for Bottle,
1939–42
Bill Traylor (1854–1947; lived and
worked in Montgomery, Alabama)

Graphite on cardboard, 17 x 14 in.

Gift of Richard L. Huffman in honor
of Valrae Reynolds, 2006 *2006.34.1*

Born into slavery on the George Traylor Plantation near Benton, Alabama, Bill
Traylor did not begin making art until he was eighty-five years old and living in
Montgomery as a free man. A self-taught artist, Traylor spent his days sitting on a
box at a busy street corner, drawing on irregular pieces of cardboard held on his lap.
He captured memories of farm life as well as the urban characters he observed
around him. He initially worked only in pencil but later expanded into watercolor,
charcoal and poster paint.

Traylor had a remarkably intuitive sense of space, acute powers of observation
and an instinct for paring forms down to their essential elements. In *Man Reaching*
for Bottle, the figure's outstretched arm and leg animate and balance the composi-
tion. Elements such as the bottles, the man's hat and one foot are drawn to the very
edges of the cardboard, lending a dynamic tension to the drawing. As in this work,
Traylor often used a straightedge to block out basic body forms like torsos and legs
before filling them in with a minimum of detail.

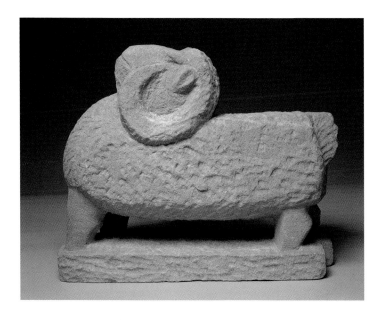

Ram, 1934–41
William Edmondson
(ca. 1870–1951; lived and
worked in Nashville,
Tennessee)

Limestone, 14 ¼ x 17 ½ x 5 ¾ in.

Bequest of Edmund L. Fuller Jr.,
1985 *85.20*

William Edmondson claims that not long after retiring in 1931 from his work as a
porter at a Nashville hospital, he received a vision from God instructing him to
become a stone carver, something he had never done before. Edmondson soon set
about fashioning his own chisels and files and locating discarded blocks of lime-
stone from abandoned buildings and quarries. He initially believed that God
intended for him to make tombstones, which he created in the form of lambs,
doves and angels, but it was not long before his subject matter grew to include an
astonishing variety of figures, animals and imaginary beasts.

Edmondson made minimal interventions into the block of stone, emphasizing
the simple volumetric shapes of his subjects and adding only the necessary amount
of detail through incised lines. The stylized forms seen in *Ram*—the gracefully
curving horns and tilted back head—lend a stately elegance to the otherwise
rough-hewn block.

With twenty-one sculptures by the artist in the collection, the Newark
Museum is one of the largest repositories of Edmondson's work in the country,
most having come to the Museum through the bequest of Edmund L. Fuller Jr., a
scholar and dealer in the field of outsider art, who also donated sculptures by
David Butler to the collection.

Construction #16, 1938
Burgoyne Diller (1906–1965;
lived and worked in New York
City and Atlantic Highlands,
New Jersey)

Wood and paint, 32 x 28 in.

Purchase 1959 The Celeste and
Armand Bartos Foundation
Fund *59.377*

Burgoyne Diller was one of the leading practitioners of geometric abstraction in the United States. As supervisor of the New York City Mural Division of the Depression-era Federal Arts Project, he was one of abstraction's great promoters as well. *Construction #16* demonstrates Diller's belief that abstraction was "the ideal realm of harmony, stability and order in which every form and spatial interval could be controlled and measured."

Inspired by the work of the nonobjective artists Piet Mondrian and Kasimir Malevich, Diller limited his palette to black, white and the primary colors, which he composed in a variety of asymmetrical, though balanced, arrangements across the rectangular grid of the picture plane. With its back open to the wall, *Construction #16* is a work that breaks down the distinctions between painting and sculpture. Painted white rectangles project outward toward the viewer, seemingly supported by the thin vertical and horizontal dowels that Diller visually strengthened by painting them powerful shades of red and yellow.

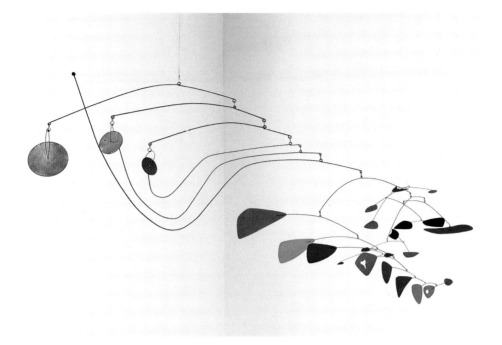

Alexander Calder's animated mobiles playfully fuse art with chance. Invented by the artist in the early 1930s, the mobile developed out of Calder's "shock," as he character-ized it, upon visiting the studio of the Dutch artist Piet Mondrian. Encountering pure abstract shapes made up of primary colors pinned to Mondrian's immaculate white walls, Calder envisioned these forms oscillating at varying speeds, an idea that inspired him to leave figuration behind for an abstract art of motion and space.

Triple Gong, like all of Calder's kinetic sculptures, is affected by its environment. The result is that the work has no set composition; it is forever changing form. As part of a series of sound mobiles Calder began in 1951, *Triple Gong* is intended to produce light, chimelike noises when air currents cause the small mallets to unpredictably strike the bronze gongs. When the Museum purchased the work from the artist in 1954, Calder wrote to the director, Katherine Coffey: "I am very glad you like the mobile, and hope it tinkles sufficiently, but <u>not too much</u>."

Triple Gong, 1951
Alexander Calder (1898–1976; lived and worked in Roxbury, Connecticut, and Paris)

Steel, aluminum, bronze, paint, 56 x 96 in.

Purchase 1954 Sophronia Anderson Bequest Fund *54.206*

Though Helen Frankenthaler became known in the 1960s for her innovative technique of pouring luminously colored, thinned oil paint across large expanses of canvas, her earlier works often exhibit a complex layering of stained, brushed and dripped paint. Unlike many of her Abstract Expressionist contemporaries, she never entirely abandoned a commitment to representation. While all of her paintings can be considered abstractions, her works frequently reference nature, especially mountains and sea. She once wrote, "I think of my pictures as explosive landscapes, worlds and distances, held on a flat surface." This vigorously painted work, with dynamic strokes and drips of thick white paint, seems to recall the turbulence of crashing surf. The patches of earth tones in the painting's foreground suggest water obliterating the land, and the few small patches of blue above suggest the sky.

Frankenthaler executed only a few canvases with collaged elements, perhaps in homage to Cubism, which greatly influenced her work. Here, an irregularly shaped piece of tan paper, painted with linear red, black and ochre forms, is collaged near the painting's upper left corner, grounding the otherwise explosive composition.

Untitled, **1955**
Helen Frankenthaler (b. 1928; lives and works in Darien, Connecticut)

Oil and paper on canvas, 54 x 70 in.

Gift of Paul Ganz, 1959 *59.406*

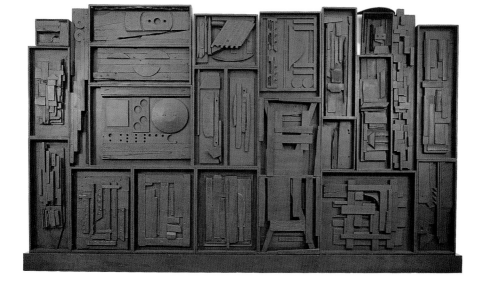

An innovator in twentieth-century American sculpture, Louise Nevelson began making the powerful wooden constructions for which she is best known when she was in her fifties. While other prominent mid-century sculptors such as Mark di Suvero and David Smith worked in welded steel and espoused a sculpture of permanence, Nevelson worked in a more fluid manner, spontaneously composing box constructions with an array of found objects—pieces of carved wood, furniture fragments and architectural ornaments—that she arranged into complex assemblages and painted one color, usually black, to unify the composition and obscure the objects' original identity. Nevelson was a lifelong student of music and modern dance, and her intuitive and performative method of sculptural construction owes much to these influences.

In *Sky Presence II*, an array of geometric shapes play across the work's modulated facade, all boxed within vertical and horizontal rectangles. While some of the boxes are densely packed with objects, others are more minimal, creating an overall rhythmic, lyrical pattern made even more complex by the play of light and shadow across the work's surface.

Sky Presence II, 1960
Louise Nevelson (1899–1988; lived and worked in New York City)

Painted wood, 113 ³/₄ x 204 in.

Purchase 2002 Helen McMahon Brady Cutting Fund and partial gift of David Anderson in honor of Samuel C. Miller *2002.2a–k*

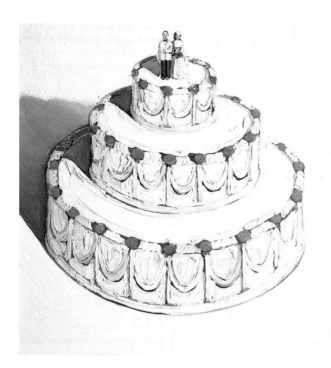

Wedding Cake, 1962
Wayne Thiebaud (b. 1920; lives
and works in Sacramento and
San Francisco, California)

Oil on canvas, 30 x 30 in.

Purchase 1963 The Sumner
Foundation for the Arts Purchase
Award *63.76*

Wayne Thiebaud was at the forefront of reintroducing representational imagery into painting in the early 1960s, after the almost singular focus on Abstract Expressionism that had prevailed since the late 1940s. His depictions of quintessentially American foods reflected the nation's growing culture of consumption, a pervasive theme in American art at the time. Because of his choice of banal subject matter—pies, cakes, bowties and sunglasses, for example—Thiebaud has often been associated with the Pop Art movement. But unlike Pop artists who preferred the slick effects of mechanical reproduction, Thiebaud used his subjects to explore composition, color, light and texture.

In *Wedding Cake*, the artist takes realism to the extreme, applying the white paint so thickly that it literally mimics the physical presence of frosting. The direct, close-up view of the cake, with all sense of setting removed, forces the viewer's attention onto the playful touches of bright color set against an otherwise white background. Thiebaud's realistic treatment of the plastic bride and groom adds to the painting's surreal quality.

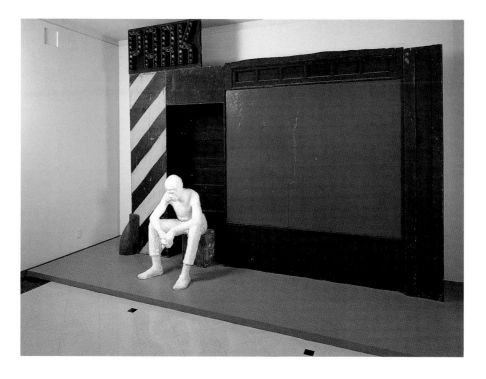

Though trained as a painter, George Segal turned to sculpture in the early 1960s. In place of traditional casting techniques, he pioneered the use of plaster-soaked gauze bandages to create molds and casts of his friends and acquaintances, placing the resulting figures in a range of tableaux that often addressed political, religious or historic themes.

Segal's stark white figures suggest both solid physical presences and ghostlike apparitions. In *The Parking Garage*, a lone attendant sits motionless and idle against a looming black and blue background, the sheer fact of his constant presence making him virtually invisible to imagined passersby. Segal's haunting, motionless sculptures speak powerfully to the isolation of the individual within contemporary society.

Segal was a seminal figure in the group of experimental artists who came together at Rutgers University in the late 1950s. Some of the first art performances, or "Happenings," took place on the South Brunswick, New Jersey, farm Segal used as his home and studio from the 1950s until his death.

The Parking Garage, 1968
George Segal (1924–2000; lived and worked in South Brunswick Township, New Jersey)

Mixed media, 120 x 158 ½ x 56 ¼ in.

Purchase 1968 with funds from the National Council on the Arts and Trustee contributions *68.191a–j*

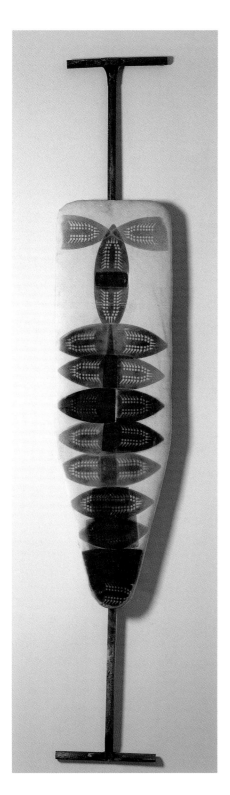

Domestic Shield V, 1992
Willie Cole (b. 1955; lives and works in Mine Hill, New Jersey)

Scorched canvas mounted on wood and ironing board, 95 x 16 x 4 in.

Purchase 1992 The Emma Fantone Fund for American Art *92.161*

While Willie Cole has incorporated a variety of domestic objects including shoes and hairdryers into his sculptures, the most frequently recurring motif in his work since the late 1980s has been that of the domestic steam iron. For the twelve works in his *Domestic Shield* series, Cole used canvas-covered ironing boards, each marked with a different pattern of iron scorch marks. To the artist, the shape of the iron sole plate and the positioning of the steam holes, which vary by manufacturer, resemble African masks and shields. The ironing boards themselves, while uncannily resembling the shields of African warriors, also recall the domestic labor of his African-American ancestors.

Cole attended Newark's highly regarded Arts High School, maintained a studio in the city's Ironbound neighborhood for over fifteen years and in 1982 cofounded an alternative space, The Works Gallery, as a gathering place for Newark's growing downtown arts scene.

Untitled, 1997–2001
Martin Puryear (b. 1941; lives
and works in Hudson Valley,
New York)

Ash, pine, cypress, rope,
132 x 44 x 143 ½ in.

Purchase 2006 Helen McMahon
Brady Cutting Fund *2006.52*

AMERICAN ART

Martin Puryear draws inspiration from simple archetypal forms such as nests, seed-pods, animals, ancient vessels and huts. In this work, the artist combines two forms—an inverted nest or basket form with a long, gently curving neck or tendril form. The body of the sculpture is made up of smoothly sanded wood slats that rise up out of a flat rough base, punctured by screws and bolts. A latticelike pattern of smooth slats and coarse disks forms the neck, which culminates in a tapered curve from which hangs a vertical rope. Although some may see this work as a dinosaur or giraffe, to the artist, this kind of specificity is not as important as a focus on the elegant contours of nature—an animal's rounded body and graceful neck, or the fruit of a plant with an elongated tendril.

This work is entirely sawn, carved, sanded and joined by hand in homage to traditional methods of construction that the artist learned in West Africa, Scandinavia and Japan.

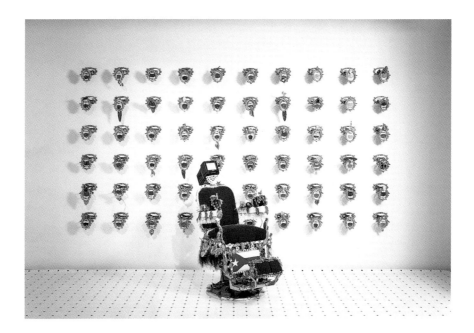

Pepón Osorio's large-scale, multimedia installations have frequently developed out of his involvement as a social worker with people in underserved urban communities. In 1994, working in a largely Puerto Rican area of Hartford, Connecticut, Osorio transformed a vacant storefront into an exaggerated version of a Puerto Rican barbershop. In *En la barbería no se llora*, the barbershop chairs were upholstered in red velvet and silkscreened with an image of a male nude; kitschy plastic toys that referenced sports, fighting and cars covered the chairs' arms, backs and footrests, and small video screens mounted on the headrests showed scenes of males playing, crying and screaming. One wall was covered with photographs of talking or screaming mouths mounted on small oval mirror frames and surrounded by more toys and tiny Puerto Rican flags.

Osorio, who is interested in "how Latino community is constructed around the notion of cultural space and how these spaces shape behavior," used the all-male barbershop as a vehicle to engage the community in a dialogue about both the construction of Latino masculinity and machismo and the way in which it plays a role in such societal concerns as gang activity and domestic violence.

Detail from *En la barbería no se llora* (*No crying allowed in the barber shop*), 1994
Pepón Osorio (b. 1955; lives and works in Philadelphia)

Mixed-media installation (barbershop chair, found objects, photographs and video monitor), 84 x 72 x 72 in.

Purchase 1996 The Members' Fund and through funds provided by AT&T New Art/New Visions 96.28.1–3

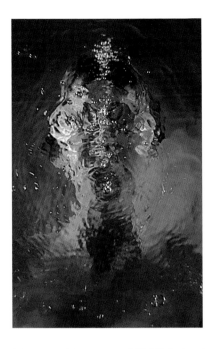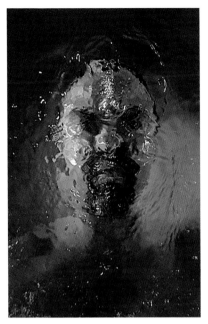

For over thirty years, Bill Viola has been at the forefront of developing the medium of video art, helping to establish it as an essential genre of contemporary visual expression. Throughout his career, he has drawn meaning and inspiration from a deep interest in Zen Buddhism, Christian mysticism and Islamic Sufism, as well as from Western medieval and Renaissance art. His works often deal with central themes of human consciousness and experience.

In 2004 Viola embarked on his most ambitious project to date when he created video projections to serve as a backdrop for a performance of Wagner's opera *Tristan and Isolde*. *Dissolution* is drawn from ideas inherent in Act III, in which the artist sees "the dissolution of the Self in the stages of dying, the delicate and excruciating process of the separation and disintegration of the physical, perceptual and conceptual components of conscious awareness." In this work, the face of a man and a woman appear on side-by-side monitors. In extreme slow motion, the viewer sees the faces sink into the water and become blurred and indistinct as the figures metaphorically move through perfection and clarity to the dissolution of self.

Dissolution, 2005
Bill Viola (b. 1951; lives and works in Long Beach, California)

Color video diptych on plasma display monitors, 48 x 40 ¼ x 3 ½ in.

Purchase 2007 C. Suydam Cutting Bequest Fund *2007.64*

Seats and Status

More than a seat, a chair can confer real or symbolic status on the sitter. The Greek *klismos*, like the one depicted on this modest Greek pot, inspired a style of furniture manufactured in the United States between 1800 and 1820. By owning such "Grecian" chairs, Americans envisioned themselves as participants in a political experiment with roots in ancient Greek democracy. New Jersey governor Marcus L. Ward had his children painted in front of a thronelike gothic armchair as a reminder of his family's distinguished history.

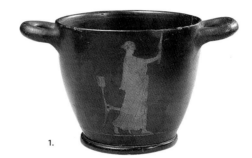

1.

1. **Attic red-figure skyphos, 500–450 B.C.**
Greece
Glazed pottery, 5 in. h. x 6 1/8 in. dia.
Gift of Louis Bamberger, 1928 *28.204*

2. **Four Children of Marcus L. Ward, 1858**
Lilly Martin Spencer (1822–1902; lived and worked in Newark, New Jersey, and New York City)
Oil on canvas, 89 ¼ x 69 ¼ in.
Bequest of Marcus L. Ward, 1921 *21.1913*

3. **Prestige chair (*akonkromfi*), 20th century**
Ghana; Asante
Wood, gold leaf, brass tacks, 46 ½ x 34 ½ x 25 in.
Purchase 1985 Wallace M. Scudder Bequest Fund and Sophronia Anderson Bequest Fund *85.362a–c*

4. **"Official's Hat" armchair (*dai shi yi*), 18th century**
China
Wood with black, gold and red lacquer, 35 ½ x 32 ½ x 25 in.
Gift of Leland C. Rhodes, 1947 *47.46*

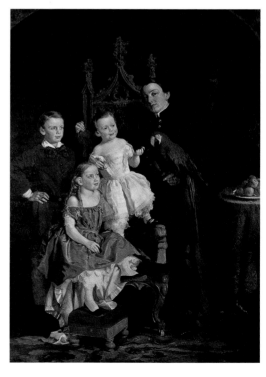

2.

The carved date on this chair's crest tied the Ward family to England's Queen Anne, who granted the City of Newark a royal charter in 1713. The richly carved and gilded Asante chair, inspired by the folding chairs of seventeenth-century Europe, which were used on state occasions, symbolized a leader's prestige and power. The shape of the back on the Chinese armchair (resembling a traditional official's hat) and the imagery on its luxuriously lacquered seat suggest this object belonged to a civil official of the ninth rank in the late Qing Dynasty. The rich lacquerwork of flowers and birds, as well as carvings in the style of the Han Dynasty, underscore the owner's status and symbolize wishes for longevity and nobility for the sitter.

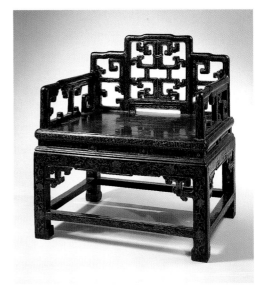

4.

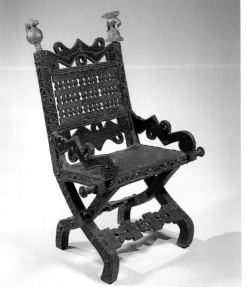

3.

Arts of the Americas

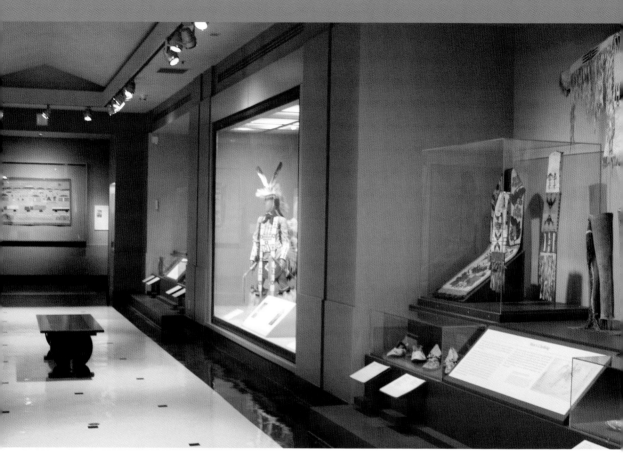

The Newark Museum's collection of the arts of the Americas includes more than four thousand works, ranging geographically from Alaska to Argentina and spanning the pre-Columbian era to the present. Of these holdings, the Museum's collection of Native North American art, begun in the 1910s, is the most comprehensive, with well over two thousand objects from the continental United States, Alaska, Hawaii and Canada. Its strengths lie in the western and central United States with cultures of the Great Lakes, Southwest, Plains and California particularly well represented. With the exception of some pre-contact works, most date from the nineteenth century to the present day. The collection is wide-ranging, including sculpture, basketry, textiles and dress, pottery, paintings and drawings. The collection of Central and South American art ranges from pre-Columbian works to late twentieth-century ceramics, household items, clothing and textiles. While not a representative

collection, its highlights include textiles from Central and South America (notably Guatemala, Peru and Bolivia), art of the Peruvian Amazon and popular arts of Mexico.

Reflecting founder John Cotton Dana's desire to bring the cultures of the world to the people of Newark, the early emphasis was on collecting a broad range of object types representing all aspects of daily life, rather than on isolated works chosen for their artistic merit. The collection began with a 1913 purchase of Pueblo textiles, pottery, baskets and *kachinas*, which formed the nucleus of an important Pueblo collection. Similarly, what was to become an extensive Native North American basket collection began with Basin/Plateau and California purchases as well as a bequest of Tlingit works. These nascent collections were strengthened in subsequent decades with gifts from collectors. Notable among these are Pueblo pottery and modern easel painting from the 1920s and 1930s, early twentieth-century material from the Kuskokwim River region of Alaska, and a significant group of California baskets, especially Pomo. Beginning in the last quarter of the twentieth century, the focus of the Museum's collecting shifted toward the acquisition of material from researchers and those with knowledge of a particular area or group. Examples of these additions include Athapascan beadwork and the arts of the Huichol and Shipibo. The Museum also expanded its representation of contemporary artistic production, often acquiring the works directly from their makers. The vitality of native arts over the last century and before, despite the enormous social and cultural changes that have occurred, is thus well documented in the Museum's collection.

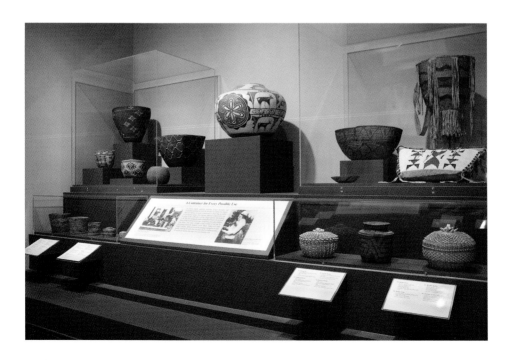

Bandolier bag, mid-19th century
Western Great Lakes; Ojibwa

Glass beads, brass buttons, wool yarn,
cotton, broadcloth, 37 x 9¾ in.

Gift of Mrs. B. S. Comstock, 1924 24.27

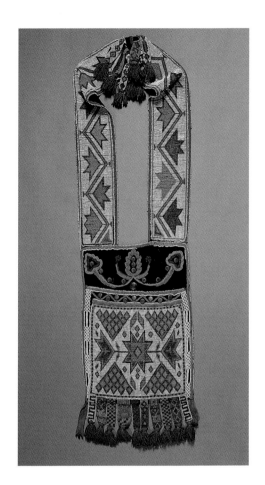

To the people of the Great Lakes region in
the second half of the nineteenth century,
bandolier bags were an essential element of
men's formal attire. Worn over the shoulder,
they became symbols of native identity.

This fine example of the bead worker's
art probably dates from the 1850s. Its pri-
mary purpose would have been decorative.
The strap and center pouch section are
woven, a demanding and time-consuming
technique, especially given the fineness of
the seed beads. The composition follows
the style of the period; above the woven
panel is a looser design in bead embroidery
that seems to float on the black background.
Delicate linear bead embroidery also
surrounds the panel. The design elements
consist of highly stylized plant forms on the
strap and geometric motifs below, all in a
symmetrical arrangement. The eight-pointed
star in the center of the composition occurs
in other beadwork from the Great Lakes
region and may have entered the native
design repertoire via rugs brought west by
settlers. The Great Lakes was an area of
intense trade in the nineteenth century as
people and ideas as well as objects circu-
lated widely.

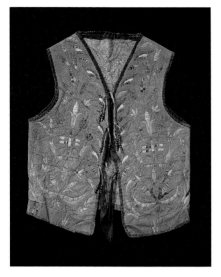
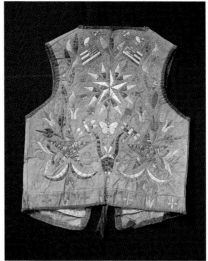

Vest, late 19th century
Montana; Blackfeet

Hide, porcupine quills,
velvet, silk, brass beads,
20 x 15 in.

Gift of Miss Amelia Elizabeth
White, 1937 *37.206*

This man's vest can be viewed as a microcosm of the many changes that took place in the lives of native people on the plains in the late nineteenth century. Vests were adopted by men after the 1870s. The decorative technique is dyed porcupine quills, a traditional method for adorning objects long before the arrival of trade beads earlier in the century. By the time this vest was made, aniline dyes were available and made the task of dyeing quills less time-consuming than natural plant dyes. Although traditional quilled designs were geometric, groups from the Great Lakes area who were pushed westward into the eastern plains introduced curving plant forms into the design repertoire of Plains artists.

Because quills are short, quilled designs always consist of small shapes. A variety of motifs appear on the front and back of this vest, some drawn from native tradition. Stars had great significance for many native peoples and were originally depicted with four points, as in the band around the lower edge. The five-pointed star, probably adopted from the American flag, was popular on the plains in the late nineteenth century. Images of American flags also found their way onto beadwork and quillwork of this period.

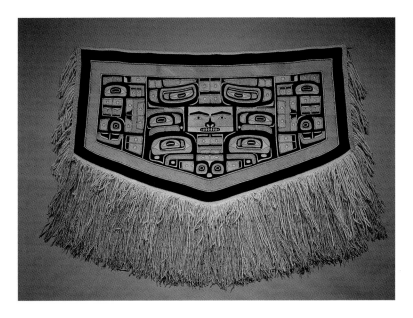

Blanket, late 19th century
Alaska; Chilkat Tlingit

Mountain goat wool, cedar bark, 34 x 62 in.
(without fringe)

Gift of Mrs C. W. Holzhauer, 1919 *19.627*

This late nineteenth-century wearing blanket is a type of textile unique to the Chilkat, a group of the Tlingit people of the Pacific Northwest. It was twined like a basket, rather than woven on a loom. The warp elements are cedar bark covered with mountain goat wool, and the wefts are wool. The design was first painted on a pattern board by a man, then copied by the woman making the blanket.

Like other Northwest Coast arts, the composition of this blanket is highly abstract and symmetrical. The characteristic outlining of every unit of the design, known as "formline," is distinctive to the arts of the Northwest Coast. These forms—such as the abstract representation of a diving whale on this blanket—relate to animals important to the weaver's family history. Every bit of space has been filled with repeated ovoid shapes suggesting eyes. Chilkat blankets were woven for ceremonial occasions and were widely traded in the Pacific Northwest. When wrapped around the shoulders of a dancing figure, these blankets are both visually striking and dynamic as the fringe sways with the movements of the wearer.

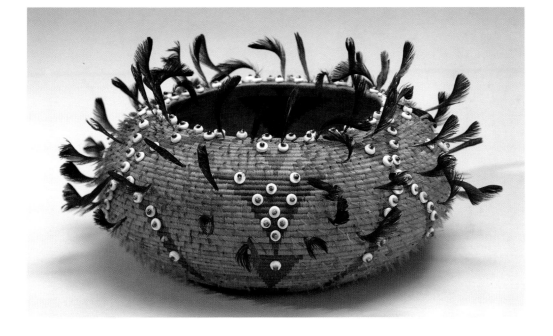

**Ceremonial basket,
early 20th century**
Upper Lake, California; Pomo

Willow, sedge, bulrush,
woodpecker and quail feathers,
clamshell, glass beads,
3½ in. h. x 7 in. dia.

Purchase 1942 Sophronia Anderson
Bequest Fund *42.576*

The Pomo, who live north of San Francisco, have excelled in making baskets for more than four hundred years. The Newark Museum's collection contains many fine examples of Pomo work made for both utilitarian and ceremonial purposes. This example, done in a three-rod coiling technique, exhibits a skillful mastery of materials and methods to create an object worthy of admiration by the recipient.

Red woodpecker feathers, prized by the Pomo, give this basket a subtle rosy glow. Fine baskets were important elements in all social and ceremonial occasions and were often destroyed when the owner's body was cremated after death. By the early twentieth century, collecting Indian baskets had become popular, and the Pomo found a ready market for their work. Today's basket makers have great difficulty locating traditional materials due to urban sprawl and the resulting loss of natural wetland habitats.

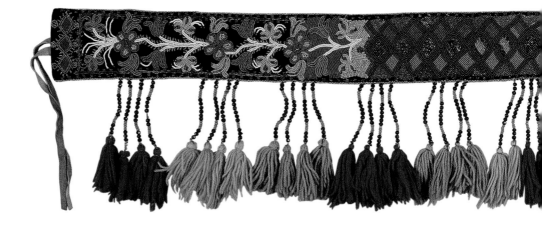

Baby belt, 1920s
Mary Johnson and Julia Loola
Fort Yukon area, Alaska; Kutchin Athapascan

Velvet, cotton, glass beads, moosehide, wool yarn,
3½ x 52 in.

Purchase 1984 Thomas L. Raymond Bequest Fund
and the Members' Fund *84.520*

A Kutchin mother carries her baby on her back using a carrying strap, known
as a baby belt, which is looped over her shoulders and tied at the neck. This
baby belt illustrates a dynamic interplay between Native American design and
technical skill and Western materials and concepts that have evolved over
several centuries.

This belt is of particular interest because it was made by two women in two
very different styles. The center section has a diamond design made with irides-
cent cut beads and derives from older geometric patterns found in quillwork.
The floral sections at either end are markedly different. They reflect the per-
sistence of flowering plant forms that were originally introduced to Native
Americans by the French nuns in Quebec, who taught embroidery based on
French styles to native girls in boarding schools. These motifs spread gradually
westward with the fur trade, reinforced along the way by missionaries. Over
time these design motifs became part of the repertoire of many groups from the
Great Lakes to the Yukon. This piece is one of a number of baby carriers in the
Museum's collection, reflecting diverse styles of construction and decoration
among Native American groups.

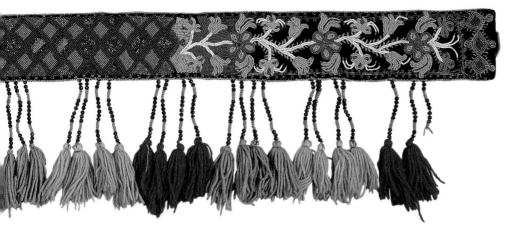

Rug, 1974–77
Juanita Tsosie (b. ca. 1930; lives
and works in the Rough Rock
Chapter area of the Navajo
Nation, Chinle, Arizona)

Wool, 42½ x 71 in.

Purchase 1977 Felix Fuld
Bequest Fund 77.4

One of the characteristics of Navajo weavers has been their unique artistic responses to cross-cultural influences. A few weavers began to create pictorial textiles in the late nineteenth century, including several depicting the newly arrived Santa Fe railroad. Almost a century later, Juanita Tsosie has captured a moment in time, Christmas on the reservation. In this whimsical work, jets and transcontinental trucks populate the landscape along with grazing sheep, geologic formations and traditional Navajo dwellings.

The Museum's collection of Southwestern textiles began in the 1910s and includes examples of all forms of Navajo textile arts, from nineteenth-century blankets made to be worn to early twentieth-century rugs made in response to the demands of a growing market. Like the horizontal banded works of the nineteenth century, the composition of this piece is open-ended; but for the border, it could extend indefinitely horizontally in both directions. In the early twentieth century, borders and other elements from the designs of oriental rugs were an innovation introduced to Navajo weavers.

Jar, 1979
Margaret Tafoya (1904–2001; lived and worked in Santa Clara Pueblo, New Mexico)

Fired clay, 7³/₄ in. h. x 7¹/₂ in. dia.

Purchase 1979 Sophronia Anderson Bequest Fund *79.620*

During her long career as a potter, Margaret Tafoya witnessed the slow decline in Pueblo pottery production in the early twentieth century and its subsequent flowering as an art form by the end of the century. As recognition came to Pueblo potters, many experimented with new shapes and techniques, but Tafoya consistently maintained a strong attachment to the traditional style of the Santa Clara Pueblo, unpainted blackware with impressed decoration.

The highly burnished surface on this elegant vessel comes from hours of polishing with a corn cob before firing. The carved design around the shoulder balances angular and curvilinear forms. Both the stepped motif and the graceful arc have been persistent elements in Pueblo pottery, dating back to the Anasazi of the twelfth century.

Tafoya learned to make pots by watching her grandmother, and she believed in teaching her children in the same way. Though, by the end of her long life, Tafoya had received numerous awards, she summed up her accomplishments modestly: "I have dressed my children with clay. It has enabled us to survive."

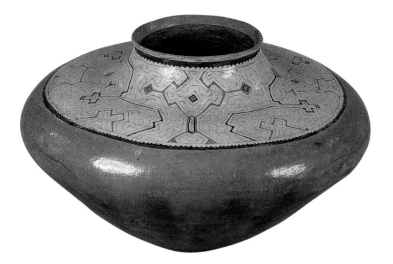

Fermentation and storage vessel (*chomo ani*), second half of the 20th century
Peru; Shipibo-Conibo

Fired clay, 20 in. h. x 36 in. dia.

Purchase 1991 Edward Weston Bequest Fund *91.344*

The Shipibo have lived along the Ucayali River, a tributary of the Amazon in eastern Peru, for at least twelve centuries. Today their culture is threatened from a variety of forces and only a few women have maintained the traditional skills to create such a masterpiece of the potter's art.

This vessel, called a *chomo ani*, was made with coiled clay from the river, mixed with temper so that the particles bond during firing. It has an almost horizontal shoulder, a tour de force for the potter since the moist coils could easily have collapsed inward as the pot dried. While the superb technical skill required to create such a vessel is impressive, for the Shipibo it is the complex painted design and not the pot itself that holds the most significance. Shipibo designs, whether they appear on pottery or textiles, always consist of meandering form lines with thinner secondary lines completely covering the surface.

This particular vessel comes from a collection begun in Peru in the 1930s. The majority of the Museum's collection of twentieth-century Shipibo arts, which includes a range of pottery types as well as textiles, was acquired through gifts and purchases, mainly in the 1980s and 1990s.

Transcendent Vessels

In every culture, vessels can have multiple meanings that reinforce or transcend function. The remarkable lacquered beaker of seventeenth-century Peru shown here provides vivid imagery of Inca life under Spanish rule. Using these beakers in pairs for traditional drinking rituals reaffirmed for the Incas a shared cultural heritage and kinship. The Bengali ritual ewer was the center

1.

2.

1. **Beaker (*kero*), 17th century**
 Peru; Inca
 Lacquered wood, 8 ¼ in. h. x 7 in. dia.
 Purchase 1948 *48.436*

2. **Ritual ewer with Manasa (Goddess of Snakes) and her family, ca. 10th century**
 Bengal region, Bangladesh
 Brass, 6 ½ x 2 ¼ x 3 ¼ in.
 Gift of Dr. David R. Nalin, 1989 *89.142*

3. **Royal palm wine container, late 19th–early 20th century**
 Cameroon; Bamileke
 Glass beads, calabash, raffia splint, cotton cloth, 33 ½ in. h. x 9 ¼ in. dia.
 Purchase 1982 Wallace M. Scudder Bequest Fund *82.115a,b*

4. ***Untitled #10*, 1995**
 Magdalene Odundo (born 1950; lives and works in England)
 Glazed ceramic, 21 ½ in. h. x 12 in. dia.
 Purchase 1996 Louis Bamberger Bequest Fund *96.29*

of, and conduit for, worship of the goddess Manasa. Young girls employed such ritual vessels, filled with holy water, to beseech the deity's protection for the greater welfare of their families. The palm wine container, opulently decorated with imported European glass beads, was both a symbol of status for a Bamileke royal and an important ritual vessel used on ceremonial occasions. Magdalene Odundo, a Kenyan-born English potter, studied Nigerian and Kenyan pottery, as well as ancient Greek and Native American Pueblo pottery. Her work transcends the utilitarian, and in its synthesis of various pottery traditions explores the sculptural potential of the vessel.

4.

3.

Arts of Africa

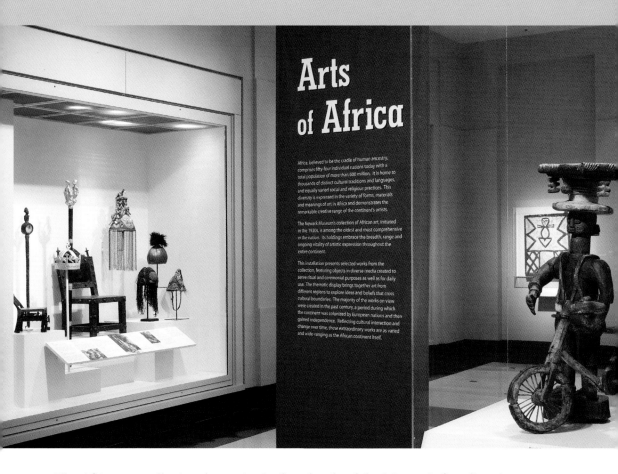

Arts of Africa

Africa, believed to be the cradle of human ancestry, comprises fifty-four individual nations today with a total population of more than 600 million. It is home to thousands of distinct cultural traditions and languages, and equally varied social and religious practices. This diversity is expressed in the variety of forms, materials and meanings of art in Africa and demonstrates the remarkable creative range of the continent's artists.

The Newark Museum's collection of African art, initiated in the 1920s, is among the oldest and most comprehensive in the nation. Its holdings embrace the breadth, range and ongoing vitality of artistic expression throughout the entire continent.

This installation presents selected works from the collection, featuring objects in diverse media created to serve ritual and ceremonial purposes as well as for daily use. The thematic display brings together art from different regions to explore ideas and beliefs that cross cultural boundaries. The majority of the works on view were created in the past century, a period during which the continent was colonized by European nations and then gained independence. Reflecting cultural interaction and change over time, these extraordinary works are as varied and wide-ranging as the African continent itself.

The African art collection, begun in the first decade of the Museum's founding, is among the most comprehensive in the United States. Continental in scope, its holdings are also distinguished by their breadth of artistic representation. Nearly four thousand works include masks and figural statuary, objects of domestic use, dress and adornment, sculpture, photography and paintings, and range from Moroccan textiles and jewelry to Ethiopian paintings to South African beadwork to contemporary video art. Most were created between the late nineteenth century and the present, an extraordinary period in Africa's history marked by European colonization and subsequent independence.

The origins of the African collection reflect founder John Cotton Dana's desire to increase public understanding of world cultures through objects, particularly those of everyday use that evidenced what he judged to be good design and artistic

innovation. From the 1920s through the 1940s, the Museum acquired works from travelers to Africa, including collections formed by missionaries and explorers. Dana himself made two collecting trips to North Africa, in 1924 and 1929. The Museum demonstrated its early commitment to African art in 1926 with the exhibition *Primitive African Art*, one of the first museum exhibitions devoted to the subject.

The African collection continued to grow through gifts and purchases in subsequent decades, and the Permanent African Gallery opened in 1970. The Museum has continued to build upon its strengths, most notably in Yoruba art, and to expand representation in select areas, such as south and east African art. A collection of more than six hundred textiles, representing the continent's significant weaving traditions as well as historic and contemporary examples of dress, ranks among the most important in the nation. This collection is especially known for more than two hundred examples of factory print textiles made in Europe and Africa during the latter half of the twentieth century. A recent emphasis has been on collecting contemporary art of Africa, broadly defined to include not only tradition-based genres but also popular art forms and examples of studio-based art made for national and international audiences.

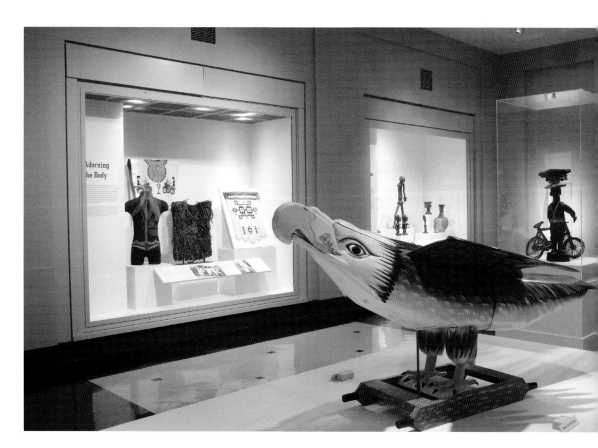

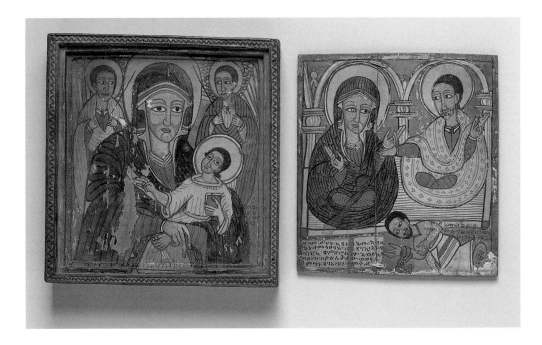

**Double-sided diptych,
mid- to late 17th century**
Gondar, Ethiopia

Tempera on wood, 6 ½ x 6 ⅝ x 1 ⅜ in.

Purchase 1990 W. Clark Symington
Bequest Fund *90.480a–c*

Since its establishment as the state religion in Ethiopia in the fourth century, Christianity has inspired the creation of sacred objects for worship or study. This small, double-sided diptych made for personal devotion is the work of an artist active in the city of Gondar, the seventeenth-century capital of Ethiopia. Its stylized figures with bold outlines and rich hues of red, blue, green and gold are characteristic of a distinctive regional style. The icon was made to be portable, closing to reveal an unpainted wooden exterior with intricately carved cruciform designs. When opened (as shown here), one side of the diptych features an image of the Virgin Mary, whose worship intensified in Ethiopia beginning in the mid-fifteenth century through the initiatives of Emperor Ze'ra Ya'equob. The main panel depicts Mary with the Christ Child, flanked by archangels Michael and Gabriel. The adjoining panel illustrates the Covenant of Mercy, the Christian belief that Mary serves as intercessor for God. To the lower right is the patron who commissioned the work, prostrate, identified in the accompanying inscription as a man named Tewodros. In associating himself with Mary, Tewodros hopes that she will intercede on his behalf.

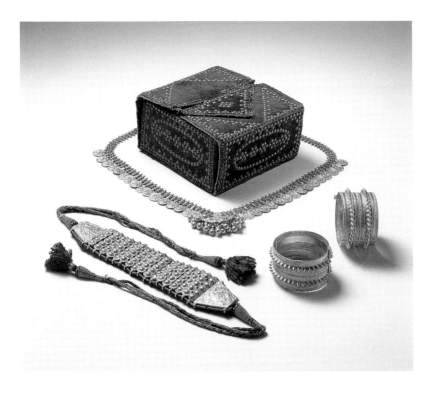

In 1884 the Sultan of Zanzibar, Seyyid Barghash bin Said, offered this remarkable suite of gold jewelry as a token of friendship to Susan Runyon Cheney. Born and raised in Newark, she had recently arrived as the new bride of Frederic Cheney, an East Indian merchant and American Consul to Zanzibar from 1870 to 1886. The necklace, bracelets and tasseled diadem are shown here along with their original velvet presentation case.

In the late nineteenth century, wealthy women associated with the ruling Arab aristocracy conspicuously wore lavish amounts of gold and silver jewelry emphasizing their privileged status. The finely worked examples of jewelry shown here reflect the confluence of cultures found in Zanzibar, an island off the coast of eastern Africa (now part of Tanzania), which had historically served as a trade center. This necklace, for example, was made by local goldsmiths from melted-down Austrian sovereigns. Its style, particularly the bead and peacock designs, reflects Indian influences.

Suite of jewelry with presentation box, ca. 1880s
Zanzibar (Tanzania)

Gold, velvet, metal, fiber, varied dimensions

Gift of Mrs. W. J. Watson, 1924
24.1837–1841

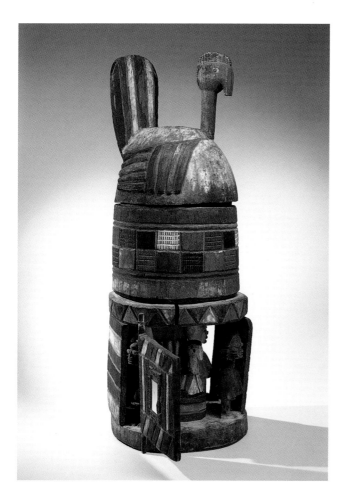

Lidded container, ca. 1890s
Nigeria; Yoruba

Wood, pigment, metal, mirror,
36 ⅝ x 14 x 14 in.

Museum Purchase 1924 *24.495*

This two-tiered container was acquired in 1899 by Walter Dormitzer, a New Jersey resident whose import-export business familiarized him with trading posts along the west coast of Africa. During his travels to Nigeria, Dormitzer received this monumental sculpture as a gift from a Yoruba leader. The topmost container takes the form of a nesting chicken or guinea hen, a bird associated with sacrificial offerings and whose imagery is repeated in the much smaller lower container. Four carved human figures with winglike arms stand as sentries peering out from behind supporting panels of the openwork base. The sculpture is accented overall with naturally derived pigments in red, black, white and blue, highlighting incised geometric designs. Described by Dormitzer as a "temple" presided over by a sacred bird, the sculpture more likely was intended for an altar or shrine, and might have held ritual offerings.

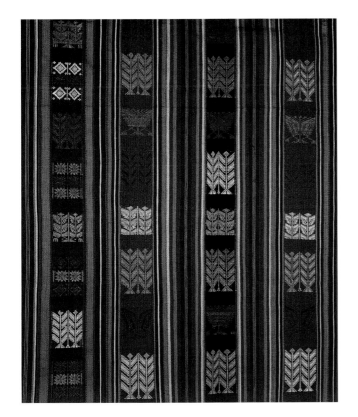

Shawl *(lamba akotofahana)*, late 19th century
Merina, Madagascar

Silk, dye, 84 x 62 in.

Museum Purchase 1928 *28.830*

Among the most celebrated of Madagascar's wide-ranging textile traditions are the silk shawls known as *lamba akotofahana*, distinguished by their brilliant colors, intricate designs and laborious method of production. These textiles were produced primarily for nobles of the Merina kingdom in central Madagascar during the nineteenth century. The weaving was done by women, who added threads of contrasting colors across the main body of the textiles to create elaborate brocade designs. Such sumptuous textiles, made from locally grown silk, were reserved for special occasions, worn as attire and also used as burial shrouds.

This fringed shawl, composed of three strips of cloth sewn together, is a rare example of an historic textile tradition that was largely abandoned in the late nineteenth century and revived only in recent decades. The cloth was acquired by John Cotton Dana in Paris in 1928 as part of a larger purchase of fifteen works representing different weaving traditions that formed the nucleus of the Museum's outstanding collection of African textiles.

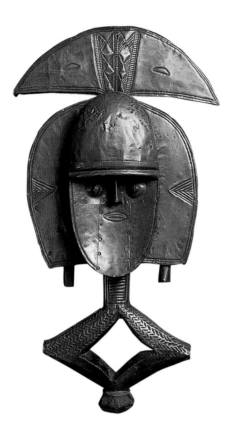

Figure from a reliquary ensemble (*mbulu ngulu*), late 19th–early 20th century
Gabon; Kota (Obamba or Mindumu)

Wood, brass, copper, 21½ x 12⅓ x 3½ in.

Albert E. Barnes Collection, Purchase 1924
24.249

During the nineteenth and early twentieth centuries, the veneration of ancestral relics in equatorial African societies inspired the creation of sculptures now considered to be among the world's greatest masterworks. Central African reliquary statuary served to amplify the presence and power of important ancestors, providing a link between the world of the living and that of the dead. This regional devotional practice found visual expression in a range of distinct genres particularly notable for their innovative artistic approaches to the human form.

Among Kota societies, reliquary statuary was sculpted in wood and sheathed in copper and brass, a technique unique to the region. The presence of precious metals, obtained through trade with Europe and used for currency in the region, reflects the ancestor's high status. Kota artists creatively employed the metal sheets and strips, often combining different metals for visual contrast and definition. Here, for example, the dramatic shift in volume between the heavy, rounded forehead covered with brass sheeting and the flattened lower half of the face is emphasized with a band of reddish copper. In its original context, this sculpture would have been placed in a basket with the bones of the important ancestor, honoring the family member.

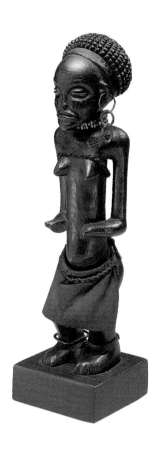

Female figure, late 19th–early 20th century
Angola or Democratic Republic of the Congo; Chokwe

Wood, fiber, metal, beads,
11 ¾ x 3 ¼ x 3 ½ in.

Purchase 2006 Helen McMahon
Brady Cutting Fund *2006.28*

Beginning in the nineteenth century, Chokwe leaders established powerful chiefdoms that extended over vast territories encompassing parts of the present-day nations of Angola, Democratic Republic of the Congo and Zambia. The increasing wealth and influence of these chieftaincies contributed to the rise of a professional class of artists who developed a refined, naturalistic style of sculpture for the Chokwe court. Recent scholarship suggests that some of these works may also have been created for religious worship, as receptacles for spiritual forces.

The master sculptor who created this exquisite representation of a female figure has imbued his subject with the noble bearing of an aristocrat. The figure's flexed legs, extended abdomen and bent arms convey a sense of dynamism. The facial features are sensitively rendered; meticulous attention was paid as well to details of coiffure and adornment, with attached elements of dress. While its style is typical of Chokwe court art, the hole on the back of its head, which may once have held a horn filled with empowering substances, indicates that the figure may have been a visual manifestation of a natural or ancestral spirit and had a ritual, rather than a political, purpose.

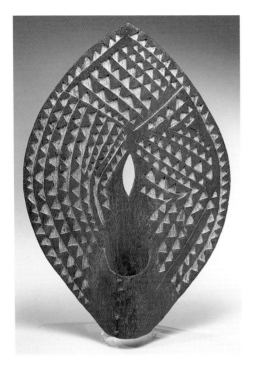
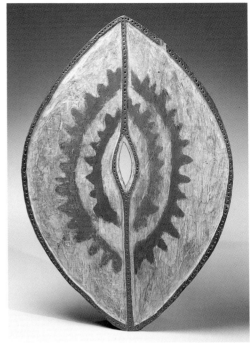

Dance shield *(ndome)*, late 19th–early 20th century
Kenya; Kikuyu

Wood, pigment, 26 x 18 x 3 ¾ in.

Gift of Mr. William Deppermann, 1956 *56.429*

This shield was created not for battle, but for dance ceremonies leading up to the initiation of Kikuyu boys. Worn on the initiate's upper left arm, the shield served as a powerful symbol of warrior status aspired to in adulthood. Its fabrication of lightweight wood, as opposed to the sturdy hide shields used in actual conflict, reminded the boy of his junior status.

Carved and painted designs on Kikuyu dance shields hold cultural and personal meaning for initiates and their families. The interior of most shields (including this example) is decorated with rows of repeating triangles accented with white pigment applied to the recesses. Scholars have speculated that the zigzags and dark–light contrasts evoke the snow-capped top of Kirinyaga (Mount Kenya), which holds a central role in Kikuyu cosmology. The exterior designs are more varied, marking local origin and peer group association. As shields were passed down from older male family members as treasured heirlooms, their painted designs were scraped off and repainted in preparation for use by the next generation of initiates.

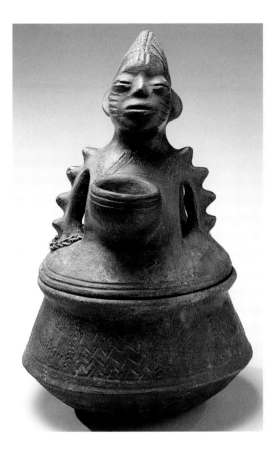

Vessel for Erinlè *(àwo ota Erinlè)*, late 19th–early 20th century

Òkè-Òdàn, Ègbádò Region, Nigeria; Yoruba

Terracotta, metal, 15 ⅞ in. h. x 8 ½ in. dia.

Purchase 1987 Thomas L. Raymond Bequest Fund *87.130a,b*

This earthenware vessel with figurative lid was created for the worship of Erinlè, a Yoruba god associated with rivers, hunting and healing. It is attributed to an unidentified female artist referred to as the "rival of Abatan," so named because her exceptional talent evokes comparison with master potter Àbátàn Odéfúnké Àyìnké Ìja (ca. 1885–1967). In this artist's skilled hands, the receptacle takes the form of a stylized female figure representing a devotee of the god, referred to as his royal wife. The intersecting arches forming her body symbolize a crown, and the deep indigo cast of the vessel alludes to Erinlè's royalty and riches. The small cup in front held a kola nut and two cowries, offerings intended to facilitate contact with the god. The vessel itself is conceived of as a life-sheltering womb, holding stones, sand and water from a river sacred to Erinlè. Given to the devotee at the time of initiation, these sacred materials possess the intrinsic power, or *ase*, of the deity.

Shawl pins, early 20th century
Algeria; Kabyle

Silver, enamel, coral, 28 ½ x 4 in.

Purchase 1930 Miss Florence Fisher *30.408*

For centuries Kabyle silversmiths have produced ornate jewelry with cloisonné enameling, a technique believed to have been introduced into Algeria from Moorish Spain. These shawl pins—richly decorated with green, gold and blue enamel and inlaid red coral—are exceptional examples of this celebrated art form. Silver was obtained by melting down coins or damaged jewelry and was regarded as a pure and auspicious material. In these examples, finely worked silver wire outlines boldly colored areas of enameled paste to create stylized floral motifs and geometric patterns. Such pins were used to fasten a woman's outer garment around her shoulder and, along with other jewelry, represented her family's wealth.

The shawl pins are part of the Museum's extensive collection of art from North Africa, an area of particular fascination for John Cotton Dana, who made two collecting trips to the region in the 1920s, acquiring textiles, rugs, jewelry, pottery, clothing, musical instruments and even a large Bedouin tent. These impressive holdings reflect the richness and diversity of arts associated with both rural and urban life in Algeria, Morocco, Tunisia and Egypt in the early twentieth century.

**Man's robe *(riga)*,
ca. 1920s**
Zaria region, Nigeria; Hausa

Cotton, wool, 57 in. length

Purchase 1929 *29.673*

In the Sokoto Caliphate (ca. 1810–1908), a powerful federation of Islamic emirates (located in the northern Nigeria of today), men's voluminous gowns played an important role in maintaining unity and central authority. Such expensive, tailored gowns with lavish embroidery, called *riga* in the Hausa language, became an integral part of investiture ceremonies and were distributed as gifts to high-ranking officials. These visually stunning "robes of honor" identified the wearer as a member of the Hausa-Fulani ruling class and have remained an important means of cultural identity from the beginning of the twentieth century to the present.

This Hausa *riga* was acquired especially for the Museum by Erick Berry, an artist and writer who lived in northern Nigeria in the 1920s with her husband Herbert Best, a British government official. The use of highly valued imported materials—white cotton damask and green wool—suggests that the robe was made for a chief or wealthy trader. Extensive embroidery on front and back reflects the Islamic culture of the Hausa and was hand-stitched by a *malam*, a male religious specialist with knowledge of Arabic writing. The designs reference political leadership and offer protective powers, including *tambari* or "king's drum," a large spiral motif on the right side of the wearer's chest that signifies Hausa chieftaincy.

Headdress, early 20th century
Bougouni region, Mali; Bamana

Wood, fiber, beads, 20 x 13 x 3 in.

Purchase 1954 Sophronia Anderson
Bequest Fund *54.372*

This headdress was part of a larger costume ensemble worn by a male performer in physically challenging dances known as *sogoni koun,* which showcased dramatic acrobatics and complex choreography. These entertaining performances, organized by associations of young Bamana men, traditionally took place after harvest or before planting.

Sogoni koun headdresses combine zoomorphic forms in creative, dynamic sculptural compositions that reference the features of antelopes, pangolins and aardvarks. Here a downward-facing animal serves as the foundation for an angular openwork creature with zigzag legs, topped by soaring curved horns. The three-tier structure is completed by a female figure precariously perched on the sloping curve of the animal's neck. This masterful sculpture was part of a group of African artworks acquired by the Museum in 1954 under the guidance of Paul Wingert, a pioneering art historian engaged in the study of African art at Columbia University. Wingert selected works he deemed "excellent from the standpoint of art," noting they would be worthy additions to a collection he regarded as overly ethnological in nature.

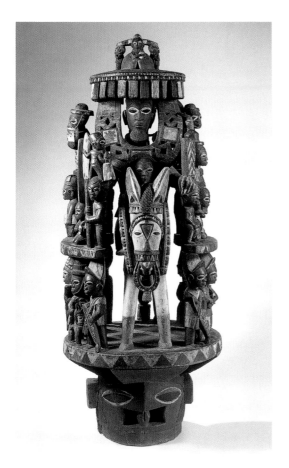

Epa headdress with warrior *(Òràngún)*, **early to mid-20th century**
Bámgbóyè (ca. 1893–1978; lived and worked in Odò-Owá, Nigeria) Èkìtì region, Nigeria; Yoruba

Wood, pigment, 55 x 24 x 24 in.

Purchase 1985 The Members' Fund
85.49

Carved from a single block of wood, this monumental headdress was created by the renowned sculptor Bámgbóyè for Epa, an annual celebration of cultural renewal among northeastern Yoruba peoples. Weighing more than fifty pounds, it would have been worn on the head of a male dancer in dramatic acrobatic performances, appearing as part of a series of masks throughout the duration of the festival. When not in use, the headdress was placed on an altar maintained by the extended family that commissioned the carving and repainted it before each performance.

The complex composition of this headdress is anchored by the towering central figure of a mounted warrior, a reference to the founding of the Èkìtì region through military might. The warrior is surrounded by a lively assemblage of thirty-six secondary figures representing a variety of social roles, including musicians, students, mothers and guards. This highly detailed masterwork showcases the technical virtuosity that earned Bámgbóyè his reputation as the foremost sculptor of Epa headdresses.

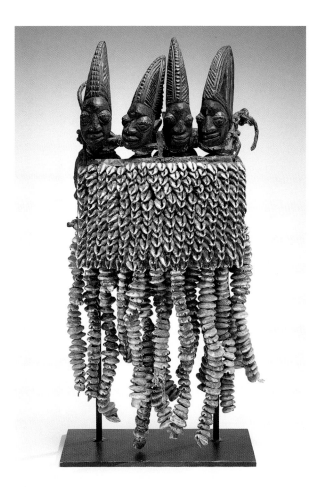

Èsù figures, early to mid-20th century
Ìgbómìnà region, Nigeria; Yoruba

Wood, cowrie shells, leather, pigment,
20 ¾ x 10 x 5 ½ in.

Gift of Bernard and Patricia Wagner,
2006 2006.39.3

The Yoruba god Èsù—divine messenger and intercessor between humans and the spiritual world—plays a critical role in traditional Yoruba religious practice. Among the Ìgbómìnà Yoruba, the deity is honored and petitioned through the use of ritual objects featuring clusters of carved figures. This example is composed of two pairs of male and female figures bound together, an allusion to Èsù's role as mediator of opposing forces. The bodies are concealed by an apron of cowries, traditional symbols of wealth and fertility that suggest the bounty that Èsù can bring to his worshippers. Such figures are carried by Èsù devotees in dances during annual festivals dedicated to the deity.

This extraordinary work is part of a major donation of Yoruba art from collectors Bernard and Patricia Wagner, a gift that has established the Newark Museum as one of the leading repositories of Yoruba art in the country, building on an existing collection begun in the 1920s.

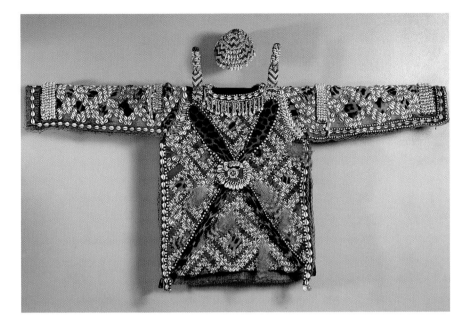

Ceremonial shirt and cap, ca. 1939–69
Nsheng, central Kasai region, Democratic Republic
of the Congo; Kuba

Raffia, cowrie shells, fur, copper, beads, feathers,
28 x 61 in. (shirt); 4 ¾ x 6 ½ in. (cap)

Purchase 1982 Wallace M. Scudder Bequest Fund
82.195a,b

The sumptuous ceremonial dress, or *bwaantshy*, of a Kuba paramount leader
literally embodied state wealth in its lavish use of cowries, imported glass beads,
precious metals, leopard skin, expensive raffia textiles and other luxury materials.
Public presentation in royal regalia was intended to recall the founding of the Kuba
dynasty in the seventeenth century, linking the present ruler to Woot, the mythical
first king.

 This shirt and cap are believed to have been worn by the Kuba king Mbop
Mabiinc maMbeky, who ruled from 1939 to 1969 in Nsheng, the royal capital. A
complete ensemble could consist of nearly fifty pieces and weigh as much as 185
pounds. Kuba royal dress is notable for its extraordinary richness of surface elaboration
and intricate play of geometric patterns, many of which hold symbolic meaning. The
open square pattern repeated over the front of this shirt, with a leopard skin center
outlined in cowries and beads, refers to Woot, symbolizing kingship and social well-
being. Despite the decline of the Kuba monarchy beginning in the late nineteenth
century and its eventual demise as a political entity, royal dress continued to be
worn on ceremonial occasions throughout the twentieth century.

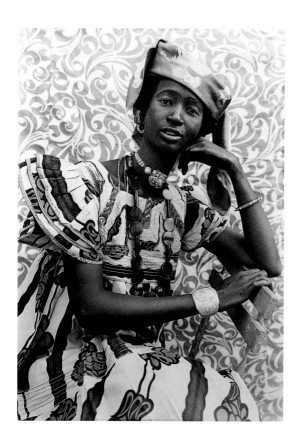

Untitled (Seated Woman), ca. 1955
(printed 1999)
Seydou Keita (1923–2001; lived and
worked in Bamako, Mali)

Gelatin silver print, 23 ⅞ x 20 in.

Purchase 1999 The Members' Fund, in
honor of Anne M. Spencer *99.26.1*

Commercial portrait studios were established in Africa as early as the 1840s, around the same time as those in Europe and North America, and dramatically multiplied in the twentieth century as Africa's urban centers grew more modern and demand for photographic portraits increased. One of the continent's most celebrated portrait photographers, Seydou Keita, operated a studio from 1948 until the early 1960s in the city of Bamako, Mali. His studio's location near a train station and popular marketplace ensured a steady stream of clients as the city rapidly urbanized during the country's transition from colonialism to independence. Keita became a highly successful commercial photographer, producing tens of thousands of portraits over the course of his career.

The young woman who sat for this portrait is dressed fashionably in a tailored dress with flared sleeves, rakish head wrap and beaded necklaces and bracelets. The juxtaposition of the vibrant pattern of the dress fabric with the printed backdrop is characteristic of Keita's signature style, as is the compositional use of a shallow depth of field. Keita's photographs, originally intimate in size and intended for his clients' personal use, were reprinted in a much larger format for the fine-art market beginning in the late 1990s.

Woman's dress ensemble, ca. 1950s
Ciskei, South Africa; Xhosa (Ngqika)

Cloth, beads, leather, metal, shells, fiber,
plastic, varied dimensions

Purchase 2003 *2003.11.1–28*

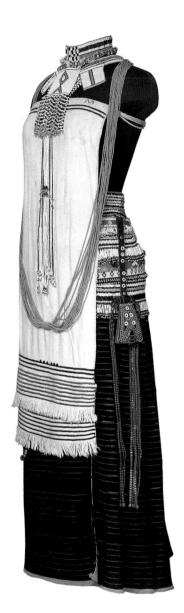

Since at least the early nineteenth century,
Xhosa women have used imported glass
beads to create spectacular dress ensembles.
The eye-dazzling beadwork also had a ritual
function and was worn on ceremonial occa-
sions to communicate with the spiritual
realm and honor ancestors. This ensemble—
consisting of 145 individual components,
not all of which are shown—was worn by a
Xhosa matron of Ngqika lineage from
Ciskei, a former South African homeland.
Until the late 1960s, a married Xhosa
woman typically wore a long skirt, turban
and, once she bore children, a cloth apron
tied around her chest. Some stylistic elements
here reflect the lasting impact of fashions and
materials brought to the Eastern Cape by
Victorian-era English settlers, particularly
represented in the full skirt, with its rows of
imported black braiding, and the clustering
of intricately beaded waistbands that form a
bustle. The fully documented ensemble was
acquired in the mid-twentieth century by
Joan Broster, a leading writer and researcher
on Xhosa beadwork whose family settled in
Xhosa territory in the 1870s.

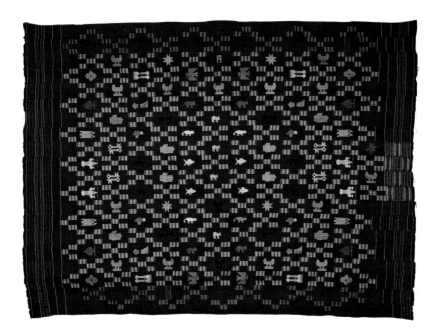

Man's *kente* cloth, 1990s
Ghana or Togo; Ewe

Cotton, 92 x 125 ¼ in.

Purchase 1997 Mrs. Parker O. Griffith
Bequest Fund *97.25.6*

Among the best known of Africa's textile traditions are the visually stunning strip-woven cloths called *kente,* made by both Asante weavers in south-central Ghana and by Ewe weavers in southeastern Ghana and neighboring Togo. While similar in process, these weaving traditions—among the world's most significant—apparently developed independently from one another over the past three centuries. Both employ a loom that allows the creation of long, narrow strips of cloth with horizontal bands of color and complex designs that "float" over the textile surface. Multiple strips are then sewn together to create large "prestige" cloths that men wrap around their bodies on special occasions.

The design of this textile, composed of twenty individual strips, is a veritable tour de force in its incorporation of images of animals, plants and household objects, each associated with a particular proverb (the use of representational motifs is a hallmark of Ewe, as opposed to Asante, *kente).* The key motif, for example, seen throughout evokes the saying "When I lock it, no one can open it," a reference to ultimate authority. This textile was purchased in 1997 at the Agbozume market in Ghana for *Wrapped in Pride: Ghanaian Kente and African-American Identity,* a major national touring exhibition organized by the Newark Museum in collaboration with UCLA's Fowler Museum.

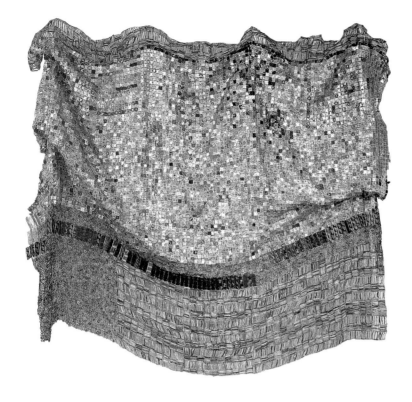

Many Came Back, 2005
El Anatsui (b. 1944; lives and works in Nsukka, Nigeria)

Aluminum (liquor bottle caps), copper wire, 84 x 115 in.

Purchase 2005 The Members' Fund *2005.34*

Over the course of a career spanning three decades, El Anatsui has had a sustained interest in the sculptural process of shaping, exploring the creative potential of different materials such as clay, wood and paint. Most recently, this internationally acclaimed artist has found inspiration in the detritus of everyday life—empty milk tins, broken cassava graters and discarded metal seals from liquor bottles. In this dazzling work, hundreds of liquor bottle seals—brightly colored and on gold and silver backings—are flattened, folded, crushed, cut and shaped, and then stitched together with copper wire. The result is a shimmering sculptural tapestry that drapes and folds softly as if it were of cloth, despite being made of metal.

For El Anatsui, the metal seals evoke Africa's long and complicated history of contact with the Western world, as alcoholic drinks were first introduced as trade items to the continent, often in return for slaves. At the same time, the color combinations and intricate patterns formed by the stitched metal seals are inspired by strip-woven textiles, such as the *kente* cloth of the artist's Ghanaian homeland and the craft of his father.

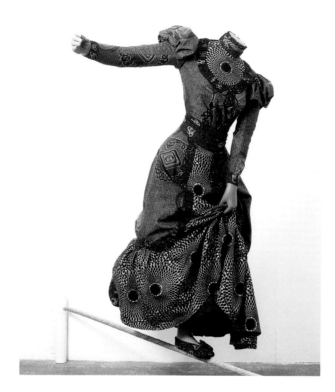

Lady Walking a Tightrope, 2006
Yinka Shonibare MBE (b. 1962; lives and works in London)

Mannequin, textile, fiber, metal,
53 ½ x 122 x 43 ¼ in.

Purchase 2007 Helen McMahon Brady Cutting Fund 2007.5a,b

Yinka Shonibare MBE is a self-described "post-colonial cultural hybrid" known for his provocative, playful explorations of race, class and cultural identity. Working in a variety of media including painting, photography, sculpture, installation and film, he is widely known for his synthesis of European fashion of the Victorian era and colorful African-print textiles. These textiles signify "Africanness" but were originally made in European factories for West African patrons during the colonial period. Shonibare's use of the eye-catching fabric highlights the entangled histories of both continents while challenging notions of African authenticity and colonial intent.

In this work, a genteel lady clothed in late nineteenth-century dress teeters delicately atop a tightrope suspended above the ground. Steadying herself with her outstretched right arm, she gathers her skirts in her left hand, revealing the dainty slippered foot upon which she balances. The work may be read as a metaphor for the artist's own balancing act, as a dual citizen of Nigeria and the United Kingdom, but may also be seen as a lighthearted reflection of Shonibare's resistance to having his work easily classified or assigned a fixed meaning.

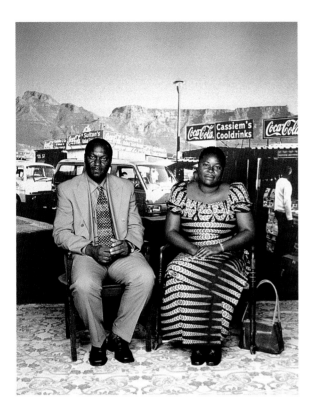

Better Lives I and II, 2003
Sue Williamson (b. 1941; lives and works
in Cape Town, South Africa)

Six DVD portraits (two groups of three),
35mm film transferred to DVD for
projection, 3.5-minute loop each

Purchase 2008 Alberto Burri Memorial Fund
established by Stanley J. Seeger
2008.5.2.1–3 and 2008.5.3.1–3

Consciously engaging the historical format of African studio portraiture, Sue
Williamson's *Better Lives* employs the medium of video to give voice and visibility
to individuals whose lives have been marked by migration and displacement. The
sitters, migrants to South Africa from other African countries, include Isabelle and
Albert Ngandu (shown here), a couple who fled the violence of the Democratic
Republic of the Congo and built a successful business in South Africa, and Deka
Yusuf Farrh, a young Somalian refugee who gave birth while imprisoned in
Namibia during her arduous journey to Cape Town.

 Their moving, often harrowing, accounts were initially recorded on audiotape
by Williamson. She later invited the participants back for formal portraits in a stu-
dio setting. Posed against a photographic backdrop of Cape Town's iconic Table
Mountain, they were asked to remain still as if sitting for a traditional long-expo-
sure photograph, and filmed as they first heard their recorded interviews played
back. Williamson's camera captures their involuntary reactions, small yet profound
movements such as finger tapping, nodding and even tears. In this way, the artist
draws attention to the convention of the video format, reminding us that this is
not a still photograph, and also links the viewer's experience to that of the partici-
pants as they both listen to these intimate personal narratives at what appears to be
the same time.

Power Dressing

For millennia, clothing has been one of the most immediate identifiers of a culture and of an individual's place within society. The majestic beaded robe worn by Yoruba ruler Oba Ademuwagun Adesida II in the 1950s reinforced his power through the use of precious imported materials and symbolic designs. When Spotted Tail, a chief of the Brulé people, led a delegation to meet with President Ulysses S. Grant about tribal lands in 1875, he wore a custom-made pair of beaded quillwork moccasins to mark both his status and the importance of the event. Similarly, the English noblewoman who chose to use exotic

1.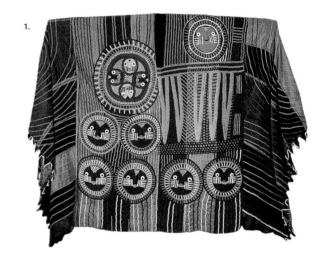

1. **Ceremonial robe of the Déjì of Akure, late 19th–early 20th century**
 Nigeria; Yoruba
 Cotton, velvet, glass beads, 50 in. length
 Purchase 1993 John J. O'Neil Bequest
 Fund & The Members' Fund *93.268*

2. **Moccasins, 1875**
 Nebraska; Brulé
 Deer hide, glass beads, porcupine quills,
 11 in. length
 Gift of the Estate of Julia B. Williamson
 and Thomas R. P. Alsop, 1963 *63.278a,b*

3. **Gown, 18th century**
 England
 Chinese silk with silk embroidery,
 52 in. length
 Gift of Isabella Graham, 1921 *21.1518*

4. ***Dream of China*, 2005**
 Wang Jin (born 1962, Datong,
 Liaoning Province, China; lives and
 works in Beijing)
 Polyvinyl chloride, monofilament,
 66 in. length
 Purchase 2007 Helen McMahon Brady
 Cutting Fund *2007.4*

2.

and costly embroidered Chinese silk for an evening gown in the late eighteenth century knew that it would immediately identify her as aristocratic and powerful. Wang Jin, a contemporary Chinese artist, evokes the embroidered silk robes of China's elite as they were reinterpreted for popular audiences in the costumes of eighteenth-century Beijing operas. By replacing the rare embroidered silk with common manufactured materials like polyvinyl chloride and fishing line, Jin comments on the changing nature of Chinese traditions.

3.

4.

Arts of Asia

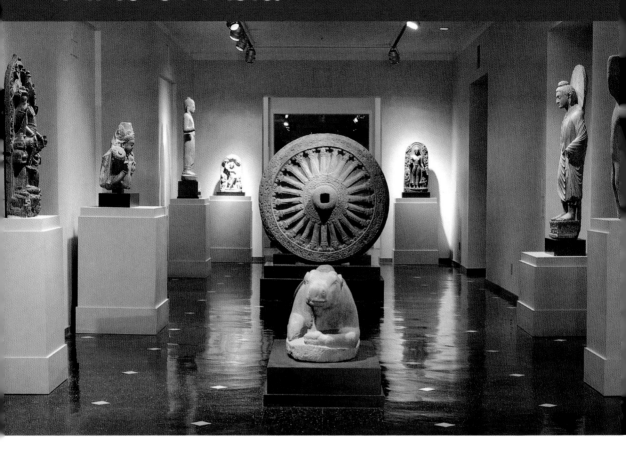

The arts of Asia have always been a central focus of the Newark Museum, as the Museum was founded with a collection of several thousand Japanese works from Newark pharmacist George T. Rockwell in 1909. Since that time, the collection has grown to nearly 30,000 objects representing all of Asia, with certain collections that are the finest of their type in the world.

The Museum's highly regarded Tibetan collection is unique in its breadth of material and the known provenance of the objects. From its first exhibition of Tibetan art in 1911—which drew over 17,000 visitors—to the reconsecration of the Tibetan Buddhist altar in the galleries by His Holiness the Fourteenth Dalai Lama in 1990, the Museum has been a leader in the field of Tibetan studies. The Japanese holdings of more than five thousand works are renowned for fine Edo period (1516–1868) prints and *netsuke*, as well as superior examples of costumes and textiles, ceramics, lacquerware and paintings. The Chinese collection has particular strengths in second-

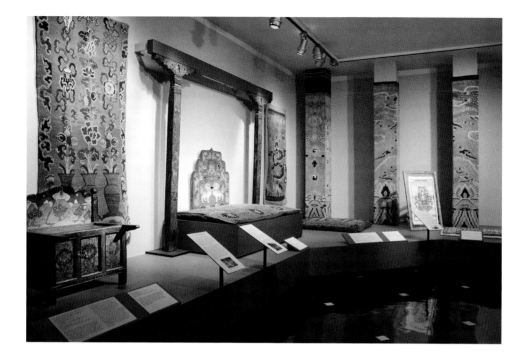

century A.D. Han to eighteenth-century Qing Dynasty ceramics, textiles and other decorative arts mostly related to the refined literati class. An unprecedented compilation of early twentieth-century Chinese crafts came to the Museum following founder John Cotton Dana's groundbreaking 1923 traveling exhibition, *China: The Land and the People*. An impressive group of South Asian devotional works donated to the Museum gave rise to the 1995 exhibition *Cooking for the Gods: The Art of Home Ritual in Bengal*. Works from South Asia in the collection range in date from the Neolithic period to the present day, with particular strengths in stone and metal devotional sculptures, though all media are represented. Several large and glorious Hindu and Buddhist stone sculptures are a highlight among the nine hundred works from Southeast Asia; an excellent collection of ceramics, textiles and decorative arts—with particular strengths in the arts of the Philippines—rounds out holdings from this region. The Korean collection numbers four hundred select objects, including some of the finest examples of Korean ceramics, costumes and textiles in all of North America. Historic photography and textiles are particular strengths of the Asian collections across all regions.

Fortunately, the majority of the objects entered the Museum's collection before the 1970s, ensuring that many rare works, not easily available for acquisition today, have been preserved for exhibition and interpretation for future generations. The Newark Museum remains committed to the continued enrichment and interpretation of its fine holdings from Asia, a heritage of ten decades of extraordinary collecting.

Zocho-ten, 9th century
Japan, early Heian period

Cypress wood, 45 ½ x 20 ¼ x 10 ¾ in.

Purchase 1965 The Members' Fund *65.73*

Zocho-ten, Guardian of the South, is one of the four protectors of the cardinal directions in the Buddhist world scheme. These four guardians appear in different warrior-like poses and garments throughout Buddhist Asia from as early as the second century. The Japanese guardians closely follow sixth- to ninth-century Chinese prototypes (wearing armor, swirling cloth undergarments, helmet and boots) that are quite unlike the actual martial costume of ninth-century Japan. The bulging eyes, vivid eyebrows and puffed cheeks of the sculpture's expressive face are also taken from Chinese imagery, which in turn was based on Indian models. The left hand originally held a sword and the right a trident. The two squat demons crushed underfoot are carved from a separate block of wood in a coarser technique.

The main figure is carved from a single block of cypress wood and was once covered with paint and gilding—elements that would have caused the image to gleam in the dark interior of a Japanese temple.

Tea bowl, ca. 1610–20

Japan

Oribe ware, glazed pottery, 2 ⅝ in. h. x 5 ⅜ in. dia.

Purchase 1926 *26.152*

John Cotton Dana purchased this deceptively unpretentious bowl at Wanamaker's Department Store in 1926. Dana probably thought it was contemporary Japanese folk ware, but further study has determined that it was made three centuries earlier for use in the tea ceremony. The tea ceremony lost popularity as Japan modernized in the late nineteenth and early twentieth century, and once-prized ceramics such as this were exported.

Chinese Chan Buddhist practitioners developed the tea ceremony as a meditation aid and a form of communal observance. Beginning in the twelfth century, elite Japanese adapted this ceremony into a sophisticated Zen art form. During the sixteenth century, tea practitioners came to prefer rough, peasant wares, and kilns began producing ceramics specifically for these patrons. The tea master Furuta Oribe (1544–1615) popularized ceramics in this style (now called "Oribe ware"). This thick-rimmed bowl was deliberately formed into the asymmetrical "shoe-shape" (*kutsu gata*) with a quickly painted curved bridge on the dented side. Viewing the bowl, touching its complex surfaces, smelling the tea and then finally tasting it are essential components of the ceremony intended to heighten the drinker's senses.

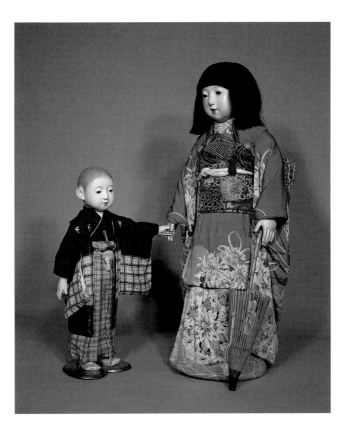

Miss Osaka and Her Little Brother, 1927
Japan

Composite heads, hands and feet, cloth bodies, printed, brocaded and embroidered silk clothes, 33 in. h. (Miss Osaka), 22 ¾ in. h. (Little Brother)

Gift of the Committee on World Friendship among Children, 1928
28.966–7

In 1927 Japanese master doll makers created fifty-eight dolls representing Japan's fifty-one prefectures, six major cities and the Imperial Household. The dolls were sent as gifts from Japanese schoolgirls to American children in response to the 12,739 "blue eyed dolls" that American children had been encouraged to send to Japan under the auspices of the Committee on World Friendship among Children in 1926–27. The Japanese dolls were larger, more lavish versions of a newly popular realistic doll, an amalgam of the American baby doll and the traditional Japanese Girl's Festival court lady doll. The committee designated the Newark Museum, in recognition of its extensive children's programming, as the recipient of the doll representing the city of Osaka. Like all the other fifty-seven Japanese dolls, Miss Osaka and her little brother were accompanied by changeable costumes of fine silk, lacquer furniture, tea sets, musical instruments and toys. Very few complete examples of this extraordinary exchange are known to survive.

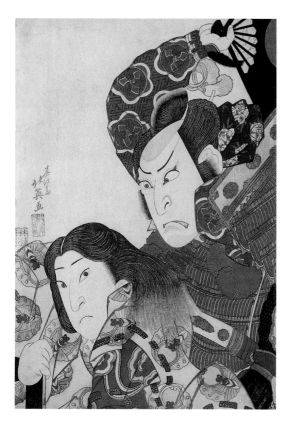

Actors Iwai Shijaku I as Atsumori and Nakamura Utaemon III as Kumagai Naozone, 1832
Shunkosai Hokuei (active 1827–37)
Japan

Woodblock print, 15 ⅞ x 10 ¾ in.

George T. Rockwell Collection, Purchase 1909
9.1888

Unusual for the fine quality of the metallic inks, embossed lines and thick paper, this print depicts two Osaka Kabuki actors and was perhaps a special edition for a limited clientele. Hokuei was a leading Osaka print designer, but his prints are rare today because in his short career he produced only 150 actor portraits. In the nineteenth century, Osaka was Tokyo's only serious rival for theatrical productions and woodblock prints. Most Japanese prints were produced in large quantities to sell as inexpensive mementos of favorite Kabuki actors or fashionable courtesans. American collectors prized these prints for their exotic subjects and bold designs. Thousands of Japanese woodblock prints were shipped to the United States in the late nineteenth century, though most foreign collectors bought from art dealers in Tokyo, not Osaka. Over one thousand prints in the George T. Rockwell Collection were acquired as part of the Newark Museum's founding collection in 1909. Rockwell, a Newark resident, purchased his Japanese prints from Newark-area sources for only pennies apiece.

Kariginu ("hunting robe"), 18th century
Japan

Gold embroidery on silk gauze, 63 in. length

Herman and Paul Jaehne Collection, Gift 1941 *41.1322*

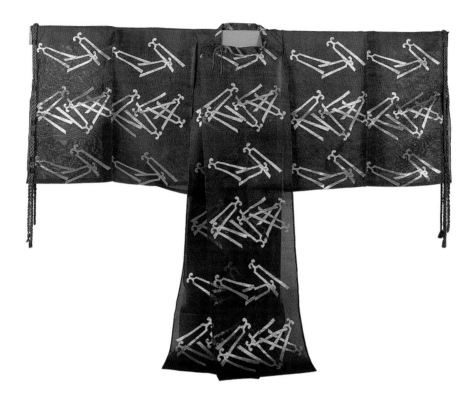

This type of gauze outer robe, originally worn by male court attendants, exemplifies the exquisite attire that was adopted as Noh theater costume. In the seventeenth and eighteenth centuries, stylized Noh theater musical dramas, much like European operas of the time, were supported by the aristocracy and Samurai elite and featured costumes of rich textiles and subtle masks. Costumes were derived from Imperial court wear, usually woven and decorated in bright colors and bold designs for better visibility on stage.

 The Newark Museum's *kariginu* features brilliant gold embroidered *koto-ji*, or bridge struts, used on the *koto*, a musical instrument. *Koto-ji* are also symbols of harmony. During the Meiji Period (1868–1912) a new type of nationalism emerged as the state pushed for modernization. A wealth of luxury goods were divested from temples, theaters and aristocratic households. Like other American collectors, the Jaehne brothers eagerly acquired these items during their residence in Japan in the late nineteenth century. Between 1938 and 1941 the Jaehnes gave several thousand Japanese objects to the Museum, forming the basis of its Asian decorative arts collection.

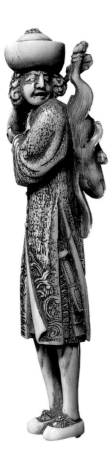

Netsuke of a Dutchman and rabbit, 18th century
Japan

Ivory, 5 ⅛ x 1 ½ x ¾ in.

Herman and Paul Jaehne Collection, Purchase and Gift 1938
38.681/4995.31

Because kimonos have no pockets, *netsuke* toggles are used to secure items (such as tobacco pouches) to the sash belt (*obi*). Intricately carved *netsuke*, with amusing or societal themes, were important and fashionable status markers for men from the seventeenth to the nineteenth century. Depictions of foreigners were a favorite *netsuke* subject. As very few outsiders were allowed into Japan at this time, their strange attire was a source of fascination reproduced widely in paintings, prints and *netsuke* carvings.

Details on this particular example suggest it was based on direct observation by the artist, rather than a generic caricature. It depicts a Dutchman returning from rabbit hunting. He wears a stiff bowl-like hat over his long curls, a tailored jacket, knickers, a knife and heeled shoes, all quite different from Japanese dress. The finely carved details and lively characterization of this *netsuke* make it a masterpiece in miniature. The Jaehne brothers, who rightly considered their *netsuke* collection to be among the finest in the world, sold and gave more than 1,200 of these objects to the Newark Museum in 1938.

Guanyin, ca. 960–1280
China, Song Dynasty

Wood with pigments and ceramic
inlay, 38 ½ x 25 ½ x 14 ½ in.

Herman and Paul Jaehne
Collection, Gift 1939 *39.370*

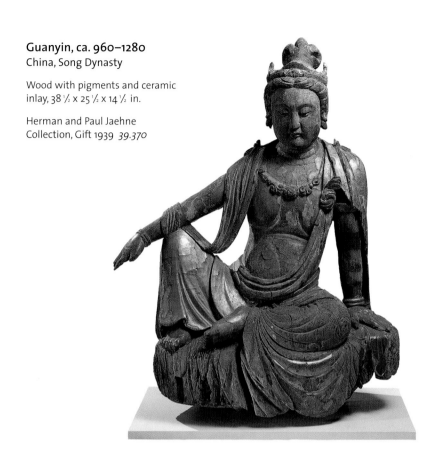

Guanyin, the Buddhist Bodhisattva of Compassion, is one of the most popular
devotional figures in all of China. One reason for this figure's popularity is that
Guanyin appears in many forms, each adapted to best assist devotees in their time
of need. Thirty-three forms of Guanyin, described in the twenty-fifth chapter of
the Lotus Sutra, informed and inspired Chinese artists' renditions of the Bodhi-
sattva (enlightened being). For example, the golden color of this sculpture's skin
and its relaxed posture reflect written descriptions of the Bodhisattva.

Painted wooden sculptures of Guanyin, accompanied by particular attendants,
were placed in front of elaborate murals incorporated into a sculptural setting at
the rear of many Buddhist temples. The murals' imagery, along with the specific
identity of the attendants, would distinguish which form of Guanyin a sculpture
represented. Countless examples of Song Dynasty wooden Guanyin statues still
survive in temples and museums in China and worldwide. The Newark Museum's
work is notable not only for the fine quality of the carving, but also for the large
amount of pigment retained on the wood surface.

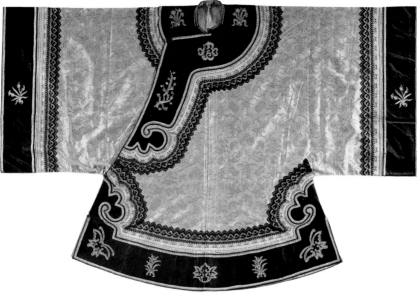

Lady's jacket, ca. 1923
China

Silk with applied decorative trim, 39 in. length

Purchase, 1923 *23.653*

This finely made lady's jacket is one of hundreds of costumes acquired in China by the Museum in preparation for the 1923 exhibition *China: The Land and the People.* John Cotton Dana turned his full impresario attention to this show, enlisting the aid of missionaries and trade organizations all over China, diplomats in Washington and numerous private collectors. Objects were organized in thematic vignettes to showcase a wide range of Chinese culture. Utilizing living tableaux, the exhibition re-created a scholar's room, a tea room and musical instrument shops. After Newark, the exhibition traveled to twenty additional American cities.

The costumes, dolls, cooking pots and other everyday objects remain in the Museum's permanent collection, a valuable record of Chinese culture before it was dramatically changed in the mid-twentieth century as a result of Mao's Cultural Revolution. A young woman in small-town southern China would have worn this body-concealing jacket quite unlike the tight *cheongsams* worn by sophisticated Shanghai ladies. Nonetheless, it was very up to date, demonstrating Art Deco influences in the shapes defined by the dramatic contrast of bright pink silk and black borders.

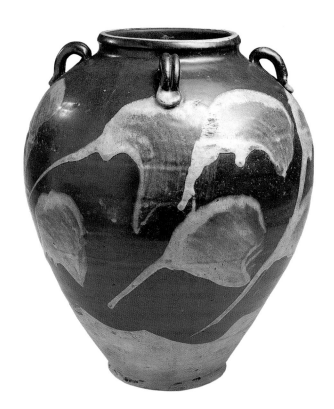

Large jar, 8th–9th century
Lushan county, Henan province,
China, Tang Dynasty

Glazed stoneware,
15 ¾ in. h. x 11 ½ in. dia.

Herman and Paul Jaehne
Collection, Gift 1941 *41.2107*

One of the finest of its type in the West, this superlative jar is notable for its large
size and fine condition. Recent excavations at the Duandian kiln, Lushan county,
Henan province in central China have turned up fragments of pottery with similar
thick brown glazes and distinctive bluish white splashes. This large-scale, exuber-
antly glazed style of pottery was popular in the eighth and ninth centuries; later the
Lushan kilns produced smaller, more subtle forms of jars, bowls and dishes. Slight
surface scratching and discoloration indicate that this jar was well used, probably
for food storage; it may have been buried after the fall of the Tang Dynasty in 906.

The Museum's collection of Chinese ceramics numbers around one thousand
pieces, with rare and fine examples from the second-century Han to the nineteenth-
century Qing Dynasties. The majority of this collection originated in the Jaehne
brothers' donations between 1938 and 1941.

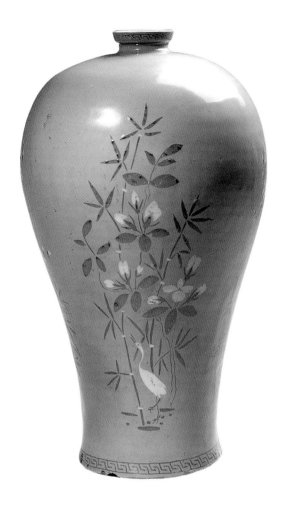

Maebyong vase with cranes and gardens design, late 12th–early 13th century
Korea

Porcelaneous stoneware with inlaid slip, celadon glaze, 16 ⅛ in. h. x 10 1/4 in. dia.

Howard W. Hayes Collection, Gift 1949
49.488

This large, flawless jar is one of the finest Korean celadon works known in the world. Although the _maebyong_ ("plum vase") shape and celadon color were introduced from China, Korean potters exaggerated the swelling shoulder and narrow base and perfected the distinctive blue-green color. Korean kilns also exploited the design potential of inlaid clays. Here white and black slips (liquid clay) fill incised lines depicting white cranes in four different garden settings. Such finely decorated celadon would have been produced only for the ruling class in the twelfth and thirteenth centuries.

Unfortunately, when the Goreyo Dynasty ended in 1392, fine palaces fell into ruins and kilns making these luxury wares lost support. How this jar survived in such superb condition is not known. It entered the collection of Judge Howard W. Hayes, a prominent Newarker, in the late nineteenth century. In 1906, the Newark Public Library exhibited this vase and other works from the Hayes Collection.

Bat Guardian, 19th century
Korea

Ink, pigments and gold on cotton cloth,
32 x 19 in.

Gift of the Honorable and Mrs. Richard Lee
Sneider, 1984 *84.374*

Mountain spirits remained important objects of traditional Korean worship
even after the fourth-century introduction of Buddhism and
Confucianism. The four guardians, representing the cardinal directions,
typically protect shrines to mountain spirits. This impish dancing figure
wears swirling ribbons, skirts and jacket, all adapted from Chinese
Buddhist imagery. The trident weapon is associated with indigenous
Korean Shamanic iconography. Much of the original paint on this work
has flaked off from moisture and wear, but the brilliance of the remaining
colors and gold, and the finesse of the drawing, indicate the hand of a
skilled artist. The Museum has a strong collection of Korean paintings that
display both charming folk sensibilities and powerful Buddhist imagery.

Pojagi, 2005
Chunghie Lee (born ca. 1960; lives in the United
States and works in the United States, Europe and
South Korea)

Cloth and screen printing, 27 ½ x 27 ½ in.

Purchase 2006 The Mr. and Mrs. William V. Griffin
Purchase Fund *2006.50.2*

Throughout the Joseon Dynasty (1392–1910), Korean women made wrapping
cloths called *pojagi*. Traditional *pojagi* could be large (to wrap and store bedding) or
small (to present gifts). Their designs might be monochromatic white-on-white
stitching or brightly colored patchwork formed with either symmetric or asymmetric
shapes. The Museum's collection encompasses older *pojagi* but also includes this
contemporary example, maintaining a Newark Museum tradition of collecting
contemporary art and craft. The artist, Chunghie Lee, has incorporated historic
pojagi designs and methods into her own multifaceted work. One side of this piece
resembles a traditional multicolored asymmetric patchwork, but the other reveals
silk-screen prints of Koreans in national dress. Lee began incorporating silkscreen
images after her 1994 Fulbright Exchange Scholarship to the Rhode Island School
of Design. Lee's oeuvre pays homage to the legions of anonymous Korean women
who produced *pojagi* before her.

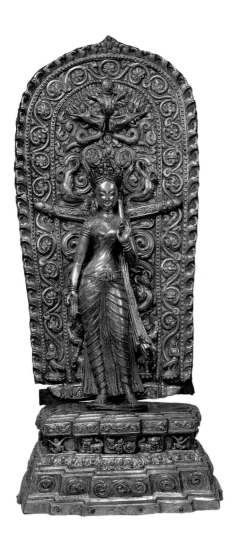

Tara, Goddess of Compassion, with throne and nimbus
Nepal, 10th–12th centuries; throne and nimbus, Tibet, 15th century or later

Assembled gilt copper, cast and hammered; silver wire and jewel inlay with traces of paint, 28 x 12 x 6 ½ in.

Dr. Albert L. Shelton Collection, Purchase 1920
20.453

This large and complex image of the Buddhist "Savioress" Tara is the product of two different workshops. The sharp line of the figure's nose, her exaggerated swelling hips and her jewelry and garments are common features of solid-cast goddess figures made by the Newar ethnic group of Nepal during the tenth and eleventh centuries. Highly prized, Newar artworks traveled far beyond their country of origin where they were revered in new ways. The nimbus and throne base reveal styles from centuries later and were probably made in Tibet; the hollow base would allow for the insertion of Tibetan consecration materials, such as sacred texts and cloth once worn by holy individuals, which would have been impossible to insert into the solid-cast statue.

The missionary Dr. Albert L. Shelton acquired the combined pieces in eastern Tibet and brought them on his 1919–20 journey to America. Shelton's often perilous work throughout eastern Tibet during the Sino-Tibetan border wars of the early twentieth century is well documented in Museum publications; the objects entrusted to him by Tibetans—both for their preservation and to raise funds for his medical mission—form the earliest portion of the Museum's famous Tibetan collection.

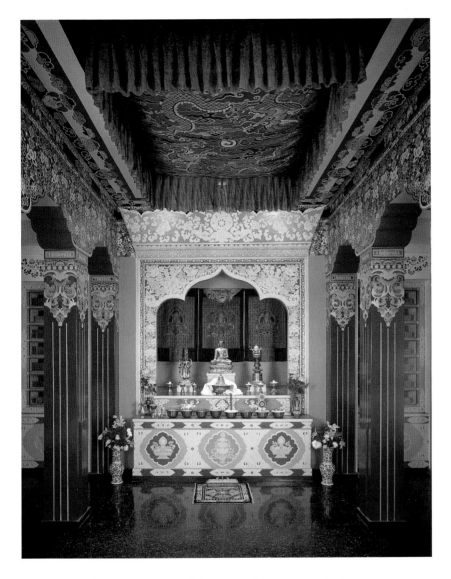

In 1935, under the auspices of the Federal Emergency Relief program, the Newark Museum constructed a Tibetan Buddhist altar to give a meaningful setting to its extensive holdings of Tibetan sacred art. When the Asian collections were installed in newly renovated galleries in 1988, the Museum commissioned a new altar that was consecrated by His Holiness the Fourteenth Dalai Lama on his third visit to the Newark Museum in 1990. Today this opulently painted altar, which houses within it portions of the 1935 original, continues to be the centerpiece of the Museum's outstanding Tibetan collections.

Tibetan Buddhist altar
Painted by Phuntsok Dorje, 1988–90

Commissioned by the Newark Museum, 1988
90.997

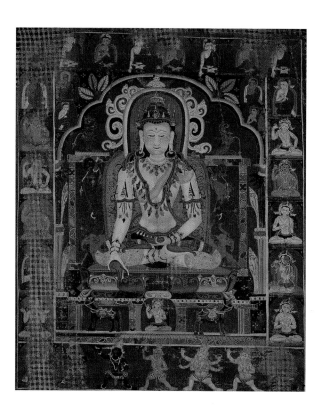

Ratnasambhava, 13th century
Central Asia

Pigments on plain cotton cloth,
16 x 13 in.

Purchase 1993 The Members'
Fund, Sophronia Anderson Fund,
William C. Symington Bequest
Fund, C. Suydam Cutting Bequest
Fund and Life Memberships
93.247

Ratnasambhava is one of five Transcendent Buddhas, each of whom heads one of the five Buddha-families that organize the vast pantheon of Mahayana Buddhism (one of the two main Buddhist schools that originated in India in the first century of this era). Ratnasambhava presides over the south and is identified by his yellow skin tone, his characteristic "wish-granting" gesture and the horses that appear at the front of the throne. Befitting his high rank, he is dressed in luxurious garments, rendered here in fine diaphanous fabric covering his legs. Four small monks flank each side of Ratnasambhava's halo; enthroned Buddhas inhabit the top row, bejeweled Bodhisattvas (enlightened beings) reside at the sides and seven fierce protectors line the bottom.

This glorious work is rare not only for the superior quality of the painting and its early date, but also for the unusual plaid cloth upon which it was painted. The cloth, as well as details such as the stylized three-leaf plant at the corner of the halo, are characteristic of paintings from the Tangut Empire in Central Asia of the twelfth and thirteenth centuries. The close stylistic links between works such as this example and early thirteenth-century central Tibetan paintings suggest that artists traveled between Tibet and the Tangut Empire to work on special projects.

Portrait of the Ngor Abbot, Ngawang Sonam Gyaltsen, ca. 1667

Ngor Pal Evam Choden Monastery, Tsang, Tibet

Colors and gold on cotton cloth, 77 ¼ x 62 ¼ in.

Purchase 1979 Anonymous Fund
79.65

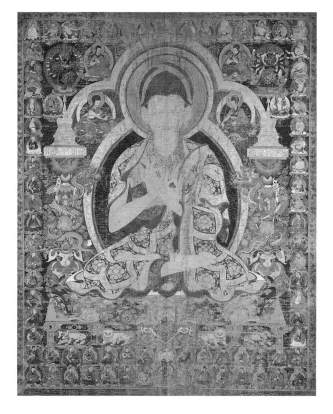

More than a majestic portrait of the central figure, Ngawang Sonam Gyaltsen, the twentieth Abbot of Ngor Pal Evam Choden Monastery, this painting reveals a three-fold record of his scholastic lineage: the teachers who taught him and those who taught his teachers, back through many generations. The first two lineages are visible within the painting in the smaller figures around the borders. These are the teachers of two significant Tibetan Buddhist texts, the Hevajra Tantra and Chakrasamvara Tantra, embodied respectively by the multi-armed, blue-hued deities in each upper corner. The sequence of teachers for both lineages begins at the center top, then cycles in a counter-clockwise direction for the Hevajra lineage and in a clockwise direction for the Chakrasamvara lineage. A third lineage of the Abbot Ngawang Sonam Gyaltsen is revealed when this portrait is understood as part of a much larger set of paintings, each depicting a different important Sakya Lama.

Following the destruction of the Ngor Pal Evam Choden Monastery complex (originally founded in 1429 in central Tibet), only a few works from this larger painting series are known to survive. However, a second Ngor Pal Evam Choden Monastery lives on, reestablished in northern India during the late twentieth century.

Almanac, 18th–19th century
Northeast Tibet

Ninety-three folios, ink and color on paper, stitched
binding, silk covers, 3 x 10 in.

Carter D. Holton Collection, Purchase 1936 *36.283*

Astrological sciences wield substantial influence over traditional Tibetan Buddhist
lunar calendars, both in liturgical events such as holidays and feast days and in the
personal lives of individuals. As in other astrological traditions, Tibetans look to
horoscopes to determine the suitability of marriage partners or auspicious times to
start business ventures. Many individuals even consult almanacs or local astrologers
to learn what days of the week, or times of day, are luckier than others.

 This beautifully painted almanac reflects the complexity, richness and importance
of this tradition. The smaller boxed symbols on this page refer to seven planets that,
as in Western traditions, are directly affiliated with the days of the week, as well as
nine "houses" that are believed to regulate rising and falling fortune. The lively
illustrations and hand-written entries reflect a devotion to the painstaking precision
required to accurately read astrological signs. Few surviving divination paintings
of comparable detail and quality are known. The excellent condition and superior
caliber of this almanac make it most rare and precious.

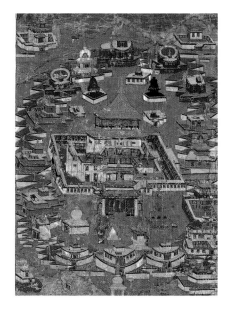

**Samye Monastery,
19th century**
Tibet

Pigment and gold on cloth,
20 ½ x 15 ¼ in.

Dr. Albert L. Shelton Collection,
Purchase 1920 *20.271*

This striking painting depicts the Samye monastic complex in central Tibet. Founded in 799 A.D. by two major historic figures, King Trisong Detsen and the great teacher Padmasambhava, Samye is the oldest Buddhist teaching monastery in Tibet. As seen in the painting, its distinctive architecture—the unusual shapes of the buildings and their positions relative to each other—reflect an idealized mandala (a diagram of sacred space). Samye consciously mirrors a Mount Meru mandala that represents the center of the world and the continents surrounding it. Annotated in golden script with the names of the Samye colleges, the painting accurately renders the monastery's appearance as reflected in historic photographs.

Other than temple and palace murals, Tibetan paintings that depict actual architectural spaces are extremely rare, as they became popular only relatively recently, in the nineteenth century. Although mural paintings of Samye survive, to date this is the only portable painting known of this important monastery and may be one of the earliest surviving Tibetan Buddhist architectural paintings.

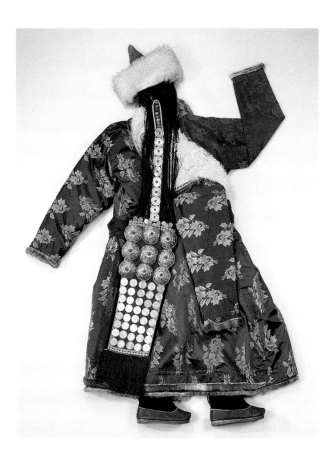

Labrang woman's ensemble, 1920–30
Northeastern Tibet

Silk brocade chupa, trimmed with otter fur; cotton sateen inner robe with sheepskin, otter fur trim; silk brocade jacket trimmed with otter fur; cotton and felt hat, lined with lambskin; padded wool headdress with silk, velvet and silk fringe, silver coins and disks, coral, glass, paste and amber; Russian leather boots with cow- and horse-hide, velvet and fringe trim, 60 in. length

Carter D. Holton Collection, Purchase 1936
36.362–82

This woman's ensemble features costly decoration suitable for a well-to-do nomad in the eastern Tibetan province of Amdo in the 1930s, and also indicates the extent of Amdo's trading partners. The inner robe of heavy sheepskin, fur turned inward for warmth, has an exterior lining of cotton sateen and an identical thin over-robe of brilliant blue and silver Chinese brocade in a European-style floral pattern. The collar is worn turned up to display Indian gold brocade facing. All of the garments are edged at cuff and hem with costly otter fur. The peaked blue cotton hat is trimmed with lambskin, and the boots, constructed of imported Russian leather and Chinese velvet, are insulated with felt.

On all occasions—even during daily milking—nomad women also wore extraordinary headdresses that displayed the family's financial status. An attached waist sash bears the headdress's weight of forty silver Chinese dollars, ten silver Chinese "quarters" and nine large dome-shaped silver "lotus petal" ornaments set with imitation coral attached with soldered metal loops. A narrow panel of wool—further adorned with large amber beads and silver disks set with coral—connects the larger rectangle to the woman's hair, which was traditionally braided into many small plaits.

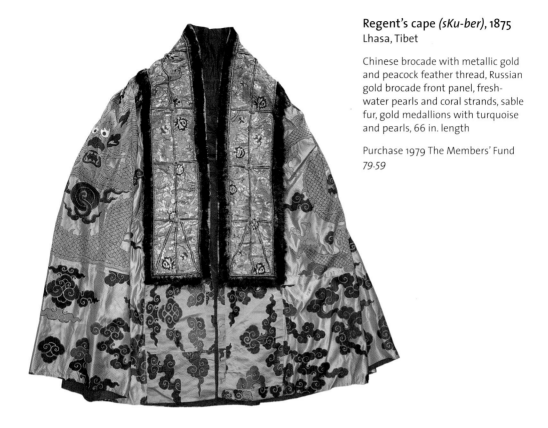

Regent's cape *(sKu-ber)*, 1875
Lhasa, Tibet

Chinese brocade with metallic gold and peacock feather thread, Russian gold brocade front panel, freshwater pearls and coral strands, sable fur, gold medallions with turquoise and pearls, 66 in. length

Purchase 1979 The Members' Fund
79.59

The single most important garment in the Museum's Tibetan collection is this sumptuous ceremonial cape (*sKu-ber*), made for Tatsa Rimpoche II, Regent of Tibet from 1875 to 1886. As regent, he ruled the country after the death of the 12th Dalai Lama and during the minority of the 13th Dalai Lama (1876–1933). Such magnificent capes were designed to be worn by a Regent, Dalai Lama, Panchen Lama or Karmapa Lama when seated upon the throne of office. Its voluminous gathered circumference flows from shoulders to throne. The robe is constructed of imported Chinese and Russian fabrics. The eighteenth-century imperial Chinese brocade, cut so that the two dragons are centered on the shoulders, had probably been stored in the Kundeling monastery in Lhasa and used for this robe only when one of its members, Tatsa Rimpoche II (Choskyi Gyaltsen Kundeling), became Regent. The front panels of contrasting cloth outlined in fur and jewels, with nine gold medallions set with turquoise and pearls positioned on crossed cords, are characteristic of *sKu-ber* ceremonial capes. Russian gold brocade was used for the front panels and is edged with freshwater pearls and coral strands and bordered by sable fur.

**Mahasiddha Virupa,
18th century**
Tibet

Appliqué silk damask and velvets
with cording and embroidery,
59 x 49 ¼ in.

Purchase 1976 Wallace M.
Scudder Bequest Fund and
The Members' Fund *76.188*

This extraordinary appliqué depicts Virupa, an Indian sage believed to have lived in
the ninth or tenth century. He is an important Mahasiddha ("Great Adept"), one of a
group that usually numbers eighty-four in the Tibetan tradition. Based on historical or
semihistorical persons, Mahasiddha are saints and miracle workers in control of mystic
forces. They are often portrayed as Indian sages, seated on cushions and animal skins
(symbolic of their vow to liberate all suffering beings), with a yoga strap around their
chests to assist meditational postures. Mahasiddhas have special importance for the
Buddhist tantric schools of Tibet as they personify the attainment of Buddhahood
within a single life.

 This appliqué was probably one of a larger group of Mahasiddha sewn to horizontal
banners for display in a monastery prayer hall. Commissioning appliqué banners is an
act of particular merit and prestige among Tibet's secular and religious leaders. Their
grand scale is crucial, as these banners are displayed in rituals and festivals. This rare
appliquéd and embroidered example is distinguished by beautiful garlands of lotus
flowers on the head and body and a tiny book of scriptures on the piled velvet hair.

Ardhanarishvara, ca. 1780–90
Jaipur, India

Ink, pigments and gold on paper,
8 ½ x 6 ½ in.

Purchase 1978 The Members' Fund
78.144

This painting depicts Ardhanarishvara, a composite form of the Hindu god Shiva and his consort Parvati. As is typical in many Indian paintings, the figures cast no shadows and are shaded as if glowing from within. Parvati is the proper left side of the figure and wears a full, floral skirt, pearl and golden jewelry along with the seductive red henna that tints her palms. The blue-skinned Shiva is the proper right side. He grasps his typical attributes, a trident and a double-sided drum. A delicate stream of water—the Ganges River—cascades from Shiva's topknot, forming the lotus-filled river in the foreground. The bell-bedecked animal vehicles, Shiva's bull and Parvati's feline, accompany the couple.

The Museum's collection of several hundred Indian paintings is of exceptional quality. Particular strengths of the collection include Ragamala works as well as Rajput and Mughal portraits.

**Burial shroud, early
20th century**
Northern Luzon,
Philippines; Isinai people

Ikat dyed cotton, 145 x 86 in.

Gift of Mrs. Sadie DeRoy
Koch and Benjamin DeRoy in
memory of their parents,
1930 *30.601*

In the mountainous region of northern Luzon, textiles were highly valued and functioned in many ways to knit communities together. They were especially important at the time of death, when the body would be wrapped in as many blankets as possible, signifying the wealth and importance of the individual and the family. Burial shrouds woven by Isinai artists were considered the most prestigious and were traded into other areas. Ikat patterning, in which the threads are tied and dyed before being woven, was reserved for funerary cloths. All stages of cloth production were in the hands of women who wove on a backstrap loom.

This blanket, which was never used for its intended purpose, is made up of four lengths sewn together, the width of each strip limited by the weaver's arm span. It is one of several that are part of an important collection from the Philippines assembled by Benjamin DeRoy between 1907 and 1914, when he was part of the American force establishing control over Northern Luzon. DeRoy's collection encompasses clothing, textiles and everyday objects as well as valuable photographs of Ifugao Province in the first decade of the twentieth century.

New Georgian bust, 19th century
New Georgia, Solomon Islands

Wood with pigments inlaid with
abalone and hair, 9 ¾ x 8 x 8 ¾ in.

Purchase 1924 *24.749*

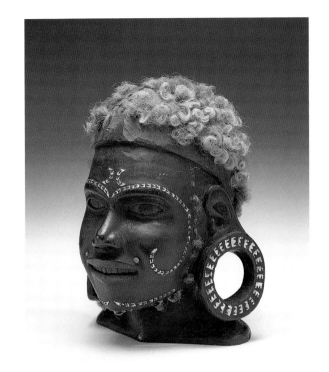

This arresting bust features delicately inlaid mother-of-pearl as well as inserted
curly hair. The inlay pattern and large disk earring-plugs mirror martial face-
painting and adornments of the people of New Georgia (the largest islands of
the Western Province of the Solomon Islands of the South Pacific). Smaller,
more abstracted figures of this type—with small arms raised to touch a chin
that juts forward—are used on the prow of canoes as figureheads, known as
nguzu nguzu, musu musu, or *toto isu.* Because of their position at the waterline
of the canoe's prow, they are believed to embody or protect against hazardous
kesoko sea spirits.

The Language of Abstraction

For thousands of years, artists have used abstract pattern to pass along traditions and express collective values. In the American Southwest, abstract design is a thousand-year-old tradition. The motifs on this Zuni pot combine a schematic, spiral bird form with geometric shapes evoking the landscape. At the turn of the twentieth century, Austrian artists merged traditional Bohemian glass techniques with modern abstract patterns based on clean lines and simple geometric motifs, as shown by this goblet. By embracing geometric patterns,

1.

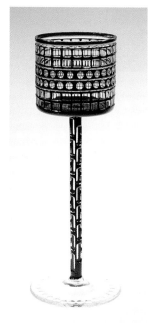

2.

1. **Strip crazy quilt, ca. 1940**
United States
Pieced wool, 61 ¾ x 49 ½ in.
Purchase 1998 The Members' Fund *98.73.2*

2. **Goblet, 1905–12**
Otto Prutscher
(1880–1949; lived and worked in Vienna)
Manufactured by Meyr's Neffe, Bohemia (now Czech Republic)
Glass, 8 ⅝ in. h. x 2 ¾ in. dia.
Purchase 1913 Jenkinson Fund *13.206*

3. **Olla, ca. 1890**
United States; Zuni
Clay, 10 ⅜ in. h. x 12 in. dia.
Purchase 1913 *13.319*

4. ***The Sign of Keeping Still*, 1953**
Charmion von Wiegand
(1899–1983; lived and worked in New York City)
Oil on canvas, 30 x 25 in.
Gift of Mr. and Mrs. Robert Miller, 1956 *56.47*

the designers of the Wiener Werkstätte in 1900s Austria aligned themselves and their patrons with a modernist machine-age aesthetic. When an anonymous African-American woman created a quilt in the late 1930s, her use of strong contrasts and asymmetry had ancient sources. The juxtaposition of light and dark forms and the improvisational design draw on African textile traditions, where asymmetry was thought to serve a protective function. In post–World War II New York, Charmion von Wiegand was drawn to the spiritual associations of abstract forms. By infusing the language of modernist abstraction with Eastern philosophies, her work accentuates the cross-cultural potential of abstract painting.

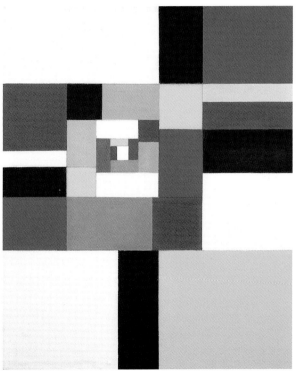

4.

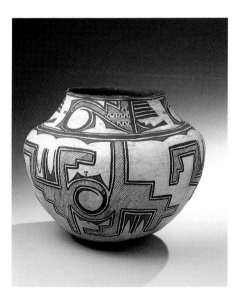

3.

Decorative Arts

The Decorative Arts collection at the Newark Museum encompasses large and diverse holdings of European and American objects, ranging from the sixteenth century to the present. Objects of daily life, both grand and mundane, handmade and the products of industry—all are embraced with equal respect. What ties the more than 48,000 disparate artifacts together is the stories they tell, the ways in which objects have both reflected and influenced daily life in the Western world since the end of the Middle Ages. Although a formal curatorial designation for the Decorative Arts department did not occur until the early 1950s, the collection began in 1911 with the purchase of a group of ceramics from the exhibition *Modern American Pottery*. The first "antique" objects also came into the collection in 1911, and ever since the old and the new have been collected in tandem. By the 1920s the collection included furniture, silver and base metals, ceramics and glass, textiles and costumes, dolls and toys and jewelry.

While objects made or used in New Jersey are an important subset of the Decorative Arts collection, the Museum has always collected internationally, acknowledging the global threads of design, craft and intersecting cultural meanings. Similarly, while founder John Cotton Dana was particularly interested in "everyday" objects—which he felt were more accessible—it has been equally a part of the Museum's mission to tell its story with objects that are technically, aesthetically or historically unique and important.

Each object, large or small, one-of-a-kind or commonplace, represents a vital part of a larger story. Thus a little blue and white 1770s teacup, inherited from the Ward family of Newark in 1921, certainly can hold tea; but it can also shed light on the life of a prominent New Jersey family, the history of porcelain manufacturing in England, the intricacies of American social aspiration and rising consumerism and the influence of China's tea-drinking in the West. After a century, we have only begun to tell all the stories the collection holds. As Dana said, "Study your teacups. The drinking vessel of everyday use is an object on which those endowed with the creative art faculty have spent time, care, labor, and high skill for many thousands of years."

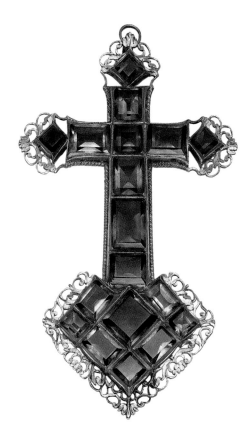

Pectoral cross, ca. 1650
Spain

Gold, amethysts, 3 ⅛ x 1 ¾ in.

The Mrs. Robert W. deForest Collection of Crosses,
Gift of her daughters, Mrs. F. deForest Stewart and
Mrs. H. R. Vermilye, 1950 *50.2236*

The Newark Museum's jewelry holdings were initiated in 1911 with the gift of a rare gold watch from Colonial New York. The collection was immeasurably enriched in 1950 and again in 1960 with the gift and bequest of two collections of crosses. While collected in the early twentieth century as devotional objects, many of these crosses now form the backbone of a wide-ranging and representative jewelry collection that spans from the late Middle Ages to the present.

This richly chased gold pendant cross demonstrates the delicate balance between the sacred and the profane in seventeenth-century jewelry. Since antiquity, amethysts have been associated with curative properties, and their rich purple color has also long been linked with royalty and religion. In the early seventeenth century it became fashionable to use flat-cut geometric stones to delineate jewelry forms, paralleling advances in gem-cutting technology. Thus, while explicitly religious in form, this particular jewel, with its opulent mount, would have been equally potent as a symbol of status for its wearer.

Three-handled cup with applied decoration, 1654

George Richardson (active 1650s; lived and worked in Wrotham, Kent, England)

Redware and white slip with lead glaze, 6 ⅛ in. h. x 5 in. dia.

Purchase 1953 *53.6*

English ceramics have always been an important part of the Decorative Arts collection, because of the English roots of America's original thirteen colonies. The earliest gift of antique English ceramics came from Sarah W. Downer, a New Jersey collector, in 1914. These early acquisitions were augmented by purchases and important gifts from Newark natives John B. Morris and his sister, Mary E. Morris, during the 1940s and 1950s. English pottery and porcelain holdings, numbering about one thousand objects, represent the range of British output between the seventeenth century and the present.

Among the rarest of English ceramics in the collection is this 1654 slip-decorated tyg (communal drinking vessel with multiple handles). One of just over two dozen surviving Wrotham examples decorated with the maker's initials, it is a masterpiece of folk pottery made for a localized clientele in rural England. The robust form and rich surface treatment embody the Baroque as it was interpreted in provincial England.

Tankard, 1691–1700
Gerrit Onckelbag (1670–1732; lived and
worked in New York City)

Silver, 7 in. h. x 5 ⅛ in. dia.

Bequest of Marcus L. Ward, 1921 *21.31*

The Marcus Ward bequest of 1921 was a seminal moment in the development of the
Decorative Arts collection. Ward, the last surviving child of New Jersey governor and
congressman Marcus L. Ward (1812–1884), left a large collection of fine and decora-
tive arts to the young museum, for which a new building was to be erected on the site
of the Ward family's Federal-style mansion in 1926.

This tankard is the oldest piece in the Museum's comprehensive American silver
collection, which surveys silver from the Colonial to the contemporary. The Onckelbag
tankard expresses the strong Dutch influence on early Colonial decorative arts in the
New York area. Silver tankards were potent status symbols for their owners because
they were essentially hard currency transformed into useful objects. The 1691 European
coin set in the lid underscores the link between silver objects and legal tender in the
Colonial mind, unlike today's silver objects, which are psychologically divorced from
cash through the prevalence of paper money and electronic finance. The only surviving
example of its kind with a New Jersey history, this tankard has probably not left the
City of Newark since it was created more than three centuries ago.

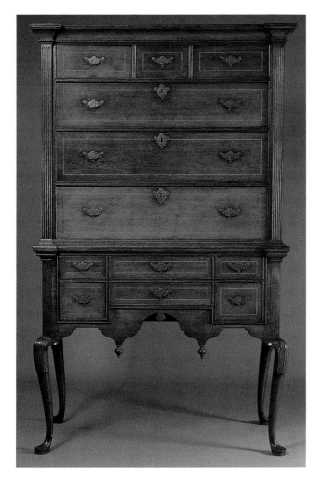

High chest of drawers, ca. 1740
Maidenhead (Lawrenceville), New Jersey

Walnut with inlaid banding, brass,
70 ¾ x 40 x 20 in.

Purchase 1963 The Members' Fund
63.27a,b

The Decorative Arts collection includes a number of important examples of early New Jersey furniture. The cabinetmaker who produced this unique chest might have trained either in Philadelphia or in nearby Chester County, for its construction and design exhibit characteristics of both places. Its history, however, ties it firmly to the Garden State.

A refined example of provincial early Georgian or Queen Anne style, with its architectural form, carved cabriole legs, inlaid banding and engraved imported brasses, this remarkable high chest of drawers was considered luxurious for its time. Although made for show, it was also practical, providing storage for clothing and linens. Thought to have been given to Catherine Smith Stevens of Maidenhead, New Jersey, as a wedding gift in the mid-1700s, it remains the only known high chest of this form with a New Jersey provenance.

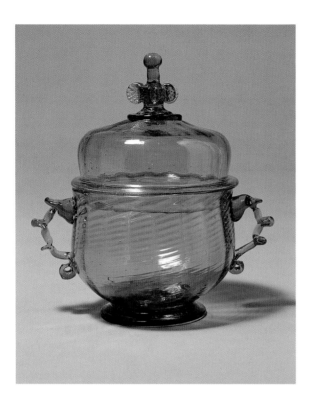

**Green sugar bowl with lid,
1750–75**
Wistarburgh Glass Works,
New Jersey

Glass, 6 ¾ in. h. x 6 in. dia.

Purchase 1966 Anonymous Fund
66.212a,b

The Museum's decorative arts holdings of more than 2,400 pieces of glass range from sixteenth-century Venetian *cristallo* to contemporary Czech glass sculpture. The interrelationship between European and American glass can be seen in this rare sugar bowl made in southern New Jersey in the middle of the eighteenth century. The mold-blown technique and use of applied tooled decoration relate closely to glass made in the Germanic principalities from which South Jersey glassmakers emigrated.

The Wistarburgh Glass Works operated from 1739 to 1777 and routinely produced mundane articles like window glass and bottles for wine and liquor. Elegant objects like this were not part of regular production, but were made as special commissions for weddings and similar events. The green color of the glass comes from impurities in the local sand, but its delicately swelling form and the dynamic outline of its handles and finial reflect the rococo taste of the mid-eighteenth century.

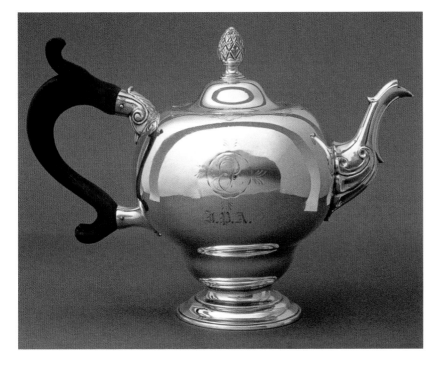

Teapot, ca. 1770
Elias Pelletreau (1726–1810; lived and worked
in Southampton, New York)

Silver, wood, 6 ¾ x 9 ½ x 5 ½ in.

Purchase 1995 Florence B. Selden Bequest and
The Members' Fund *95.29*

Since the 1921 Marcus Ward bequest of the first early silver, the Museum has con-
tinued to seek prime examples of the work of Colonial and Federal silversmiths.
Silver in Colonial America was scarce and thus conferred high status on its owner.
Tea sets as such did not exist in this period, and a single silver teapot would have
been a great luxury.

Huguenot silversmith Elias Pelletreau trained under fellow Huguenot Simeon
Soumaine in New York, and then set up his shop at the eastern end of Long Island.
He made this elegant rococo teapot for his own use in the years before the
American Revolutionary War. Its inverted double-bellied form, curvaceous handle
and spout and refined rococo engraving would have made this an especially opulent
example of its time. At Pelletreau's death in 1810, he left the teapot to his eldest
child, his daughter, Jane. The teapot descended through several generations until it
was sold to the Museum by Pelletreau's descendants.

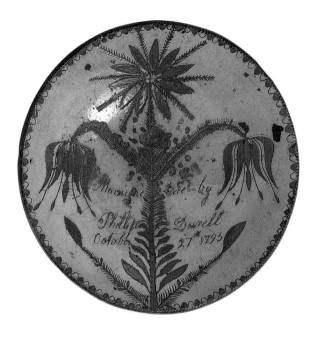

Charger with sgrafitto decoration, 1793
Phillip Durell (active 1780s and 1790s; lived and
worked in Elizabeth, New Jersey)

Redware with white slip, lead glaze, 14 in. dia.

Purchase 1948 John J. O'Neill Bequest Fund *48.440*

The history of New Jersey ceramics is represented in the Museum's collection by
nearly three thousand objects, from Colonial chamber pots to contemporary ceram-
ic sculpture. An icon of this group is the only known piece of documented New
Jersey sgrafitto, or scratch-decorated pottery, purchased from a landmark exhibition
organized by the Museum in 1947, *The Pottery and Porcelain of New Jersey*.

Phillip Durell relocated to Elizabeth from New York City in the early 1780s and
probably produced the plain utilitarian redware that was a staple of the preindustrial
American kitchen. By adding a layer of white slip (liquefied clay) to this piece and
then cutting decorative designs through the slip, Durell produced a dish that was as
decorative as it was useful. Related to Pennsylvania German sgrafitto of the same
period, Durell's work seems to have been a rare example of a non-German artisan
producing this distinctively Germanic folk pottery.

Monumental urn with ormolu mounts, 1804–09
Imperial Porcelain Manufactory, Sèvres, France

Porcelain, enamel, bronze, 37 ½ x 10 x 19 ¾ in.

Gift of Mrs. William J. Clark, 1933 *33.410a,b*

Some 1,100 pieces of European pottery and porcelain in the Museum's collection trace ceramic design and technology from the 1500s to the twentieth century. From the moment porcelain was first commercially developed in Europe at Meissen, Germany, in the early 1700s, professional decorators transformed the hard, white clay body into a canvas for brilliant color and glittering gold work. The decoration of porcelain with fired-on enamels flourished in the eighteenth century, both in Europe and in Asia, and established an abiding taste for this kind of work.

This monumental urn, with its finely painted mythological scenes and splendid gilt bronze mounts, embodies the grandest neoclassical taste of the early 1800s. One of a pair donated in 1933, it was purchased by a New Jersey family at the celebrated 1882 London auction of the contents of Hamilton Palace, the Duke of Hamilton's country house. This sort of aristocratic European porcelain inspired American porcelain manufacturers to aesthetic and technical advances in the late nineteenth century.

Parlor chair in the gothic style, ca. 1850
John Jelliff (1813–1893; lived and worked in Newark, New Jersey)

Rosewood-grained walnut, 58 ¾ x 18 ⅜ x 21 ½ in.

Gift of the Estate of Florence Peshine Eagleton, 1954 *54.13*

In the early 1920s the Museum received its first piece of furniture attributed to John Jelliff's Newark furniture factory. From that beginning grew the most comprehensive group of objects and documents in the country associated with this well-known Victorian furniture maker. Apprenticed to the Crane brothers in Newark in 1829, Jelliff established his own shop by the mid-1830s. Until his retirement in the 1880s, he ran Newark's most important furniture factory, manufacturing both for local families and, after the Civil War, for retailers across the country.

This chair has special significance to the collection because its donor was both a Newark Museum trustee and Jelliff's granddaughter. It is the earliest known piece attributable to Jelliff's shop, produced for his daughter Mary Jelliff Peshine in the late 1840s or early 1850s. The gothic design of the chair is a testament to the family's Anglican roots and their affiliation with Trinity Episcopal Church (now Trinity & St. Philip's Cathedral) in downtown Newark.

Étagère sideboard, ca. 1854
Alexander Roux (1813–1886; lived and worked in New York City)

Walnut, 90 ½ x 72 x 23 ½ in.

Purchase 1992 The Members' Fund *92.72a–h*

The Museum's nineteenth-century furniture holdings document every major style and form of this "century of revivals." Starting with gifts from local families in the early 1920s, the Decorative Arts collection has acquired examples by famed American makers such as John Henry Belter, Herter Brothers, Alexander Roux, J. & J. W. Meeks and Mitchell & Rammelsberg.

French born and trained, Alexander Roux was one of the most important cabinetmakers in mid-Victorian New York, translating French styles into objects that fulfilled his American clients' tastes. Having shown a nearly identical sideboard at the 1853 Crystal Palace Exhibition in New York, Roux received a commission for a pair of sideboards, probably from the Astor family, on which he sculpted the wide range of the fruit, vegetables and game available in America's urban centers. Covered in superb naturalistic carving, the Newark Museum's sideboard is topped by the head of a steer. Its mate, now in the collection of the Metropolitan Museum of Art, is topped by a stag's head.

**Testimonial jewel with
the arms of the City of
Newark, 1868**
James Madison Durand & Co.,
Newark, New Jersey

Gold, 3 x 1 ⅝ in.

Gift of Vivian Sauvage and his
sisters, 1937 *37.590a,b*

By the middle of the nineteenth century, Newark was
firmly established as the center for fine jewelry production
in the United States. The growing number of workshops
in Newark drew their skilled labor from the swell of
German immigrants that gradually transformed the city's
population starting in the 1840s. The Newark Museum's
collection of Newark-made jewelry is unsurpassed.

This unique testimonial jewel is documented in a
contemporary newspaper account of its presentation to
Thomas B. Peddie, mayor of the City of Newark from
1866 to 1869, a self-made man and an ardent promoter of
the city's industries. It is also a testament to the skills of
Newark's jewelry makers. The exquisitely chased oak leaves
represent strength and perseverance, while the laurel leaves
represent triumph. The beehive at the top was a common
symbol of industry in the nineteenth century. James
Madison Durand was a nephew of Asher B. Durand, the
celebrated New Jersey landscape painter. His firm formed
close ties with New York jewelry retailers and also manu-
factured for Tiffany & Co.

Sideboard dish in the Henri II style, 1875
Tiffany & Co., New York City

Silver, copper, gold, niello, 20 1/8 in. dia.

Purchase 1998 Avis Miller Pond Bequest and Membership Endowment Fund *98.1*

This remarkable sideboard dish epitomizes America's fascination with European aristocracy and its desire to be seen as sophisticated during the Gilded Age. Tiffany & Co. triumphed at the American Centennial Exhibition in Philadelphia in 1876 by beating its European competition for the gold medal in silver.

This large dish, inlaid with gold, copper and a black alloy called niello, depicts a French princess of the 1500s listening to two "loves" and trying to decide which of the two she should heed. It was inspired by a popular French romance novel of 1678, *La Princesse de Clèves*. Possibly conceived by the French designer Eugène Soligny, who produced many of Tiffany's most ambitious sculpted pieces, the charger was shown at the Paris Exposition Universelle in 1878, where it was bought by an American collector, Mary Jane Morgan. When purchased by the Newark Museum in 1998, it had not been publically seen for more than a century.

Wedding album quilt, 1864
Mary Nevius Potter and others,
Pottersville, New Jersey

Pieced and appliqué cotton,
86 x 86 in.

Gift of Mr. and Mrs. Irvin F.
Sewers, 1974 *74.212*

*This quilt was conserved through
the generosity of the Garden
State Quilters*

The Museum's celebrated quilt collection began in 1918 with the purchase of a two-color pieced bedcover of quilted wool. Since that year the collection has grown to encompass a wide range of American quilts from the eighteenth century to the present day, from folk art to fine art. This striking quilt, made as a bridal gift, was created from individual blocks, each one worked by a different woman. Made during the Civil War, the quilt incorporates an American flag, indicating the quilters' support for the Union. "Quiltings" provided opportunities for women to share their opinions and beliefs on a variety of subjects. Quilters often incorporated political or religious themes into the overall design of their work, demonstrating the quilt's importance as a sanctioned vehicle for women's views in the nineteenth century.

Rhythm/Color: Spanish Dance, 1985
Michael James (born 1949; lives and works in
Lincoln, Nebraska)

Cotton and silk, machine pieced, 96 ½ x 96 ¾ in.

Purchase 1985 Louis Comfort Tiffany Foundation *85.52*

The Newark Museum began collecting quilts and coverlets in 1918, interpreting them as domestic textiles, folk art and graphic design. In 1965 it mounted the first museum exhibition in America that highlighted the relationship between quilts and the contemporary Op Art movement. Today the Museum's quilt collection is nationally known and includes a wide range of quilts, mostly by women, from across the United States.

This quilt was commissioned by the Museum in 1984, and is one of a series Michael James created in the mid-1980s related to the idea of dance. One of the few male quilters in the collection, James trained as a painter. He explored the quilt as an exercise in color theory, adapting traditional strip-quilting techniques. The virtuosity of James' use of color to create vibrant, painterly effects, as well as his technical skill, won the attention of the Louis Comfort Tiffany Foundation and resulted in the first museum commission of James' work.

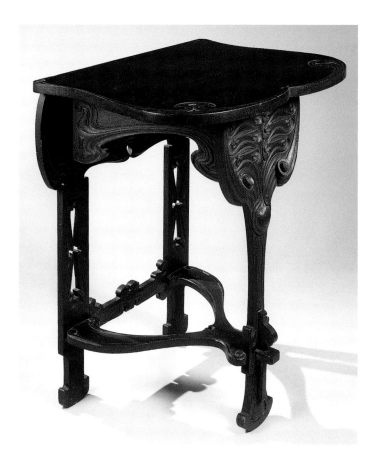

Console table, 1900–05
Charles Rohlfs (1853–1936;
lived and worked in Buffalo,
New York)

Oak, 30 x 24 ¾ x 19 ⅛ in.

Purchase 1999 Membership
Endowment Fund *99.80*

Acquired during the Museum's ninetieth anniversary observance, the Rohlfs table represents the Decorative Arts department's ongoing commitment to acquiring masterworks of design and craftsmanship in American furniture.

One of only two known examples of this form by Rohlfs, this console table exemplifies the Buffalo furniture maker's distinctive and eccentric combination of the medieval and the modern-day. Rohlfs was the only Arts and Crafts furniture maker in America to explore the sculptural possibilities of the whiplash curves of the Art Nouveau in his designs. If his design is more medieval in its construction, with its use of slablike forms attached with obvious wooden fasteners, the sinuous lines and writhing carved work draw inspiration from contemporary European modern design. The high-relief carving of the front panel above the leg is unusually elaborate, even for Rohlfs.

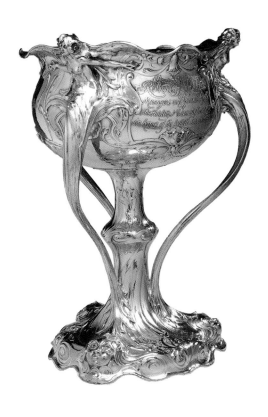

Presentation cup, 1905
William Christmas Codman, Robert Bain
and F. O. Erichsen for Gorham Manufacturing
Company, Providence, Rhode Island

Silver, 18 in. h. x 12 ¾ in. dia.

Gift of James R. Hillas, 1967 *67.115*

More solid silver objects were made at the turn of the twentieth century than at any
other time, as the cost of raw silver was relatively low and thus affordable to a vast
middle-class market. The Museum has collected a wide range of silver objects, from
modest to magnificent. Well-known mass-market silver firms, such as Newark's own
Unger Brothers and William B. Kerr Company, are well represented.

In contrast to inexpensive factory-made silver, William Christmas Codman,
working for Gorham Manufacturing Company, America's largest silver manufacturer,
created a special workshop within the Gorham factory to produce a line of handmade
silver called *martelé* ("hammered"). This cup, made in 1905, is one of the finest
products of that workshop, and embodies the symbolism and sense of movement that
characterize the Art Nouveau. Three mermaids swirl up out of roiling seas, their
sweeping contours framed with the iconic whiplash lines of the style. The poppies
behind their ears, symbols of opium, underscore their otherworldly nature.

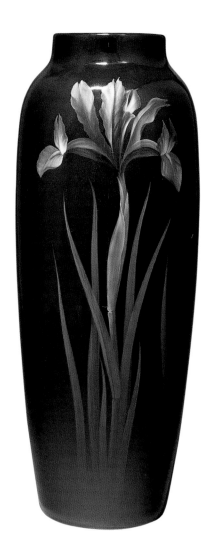

Black Iris vase, 1909
Rookwood Pottery, Cincinnati, Ohio

Porcelaneous earthenware, slip, 13 ¾ in. h. x 5 ½ in. dia.

Purchase 1914 *14.446*

Modern ceramics captivated the imagination of John Cotton Dana because he felt it was an accessible art form. Rookwood was the most famous of the art potteries founded during America's Arts and Crafts movement at the end of the nineteenth century. Using highly skilled decorators and a brilliant team of glaze chemists, Rookwood had established its dominance by the time this vase was made. The pottery was internationally known for its naturalistic decoration, which capitalized on a clear overglaze that imparted a jewel-like depth.

Made the year the Newark Museum was founded, this vase may well be the finest example of its kind, with a flawless black glaze that shades to vivid lapis lazuli blue. The superb underglaze slip decoration by Rookwood artist Carl Schmidt appealed strongly to Dana, who appreciated the vase's limpid realism, with its overtones of both Art Nouveau and Japanese aesthetics. It was purchased from a local art dealer, and was first shown at the Museum in 1912.

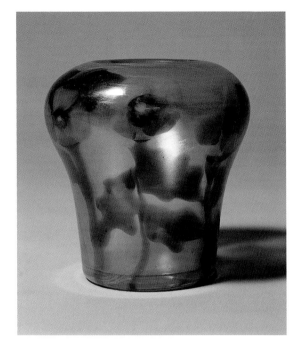

Vase with internal decoration of poppies, ca. 1913

Louis Comfort Tiffany (1848–1933; lived and worked in New York City) for Tiffany Furnaces, Corona, New York

Glass, 6 ½ in. h. x 6 in. dia.

Gift of Mr. and Mrs. Ethan Alyea, 1966
66.473

An important gift of art glass from a New Jersey collection in 1966 provided the Museum with a strong representation of the range of glass from Louis Comfort Tiffany's workshops. Although Tiffany is often described as an Art Nouveau designer, it is really in the context of the American Arts and Crafts movement that his work is best appreciated. Tiffany's lifelong passion for color and fascination with natural forms are both apparent in this vase.

The vase, made for exhibition in about 1913, is an especially fine example of Tiffany's so-called paperweight glass. Tiffany's craftsmen perfected the technique of encasing pieces of opaque colored glass in two layers of transparent glass. The faint gold iridescence evokes the weathered surface of ancient glass that Tiffany admired and tried to replicate. The stylized poppies, symbols of languor and forgetfulness, are treated as slightly abstracted natural specimens.

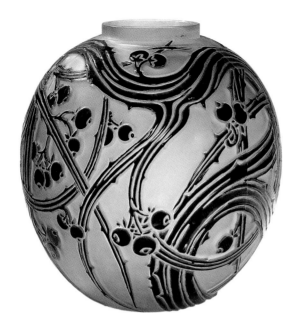

Les Baies (vase), ca. 1928
René Lalique (1860–1945; lived and worked in Paris and Wingen-sur-Moder, France)

Glass, enamel, 10 ¾ in. h. x 10 in. dia.

Purchase 1929 *29.1345*

The Newark Museum was one of the first museums in the nation to purchase Lalique glass, acquiring four small pieces in 1913 from Haviland & Co. in New York. In 1929 the Museum collaborated with L. Bamberger & Company, the famed Newark department store, on a series of exhibitions of modern European design. To enhance its growing collection of modern decorative arts, the Museum purchased a number of silver, ceramic and glass pieces from these exhibitions, including this vase.

René Lalique, revered for his avant-garde jewelry before 1913, had begun making glass in the 1910s. His elegant, stylized modernism, which embraced representational motifs rather than pure abstraction, appealed to American taste and was immediately popular. This vase, with its swirling geometry of berry branches (*baies* in French) and its cool, black and gray coloration, contrasting shiny and matte surfaces, is a signature Lalique design.

Antelope Jar, 1979
Adrian Saxe (born 1943; lives and
works in Los Angeles)

Porcelain, stoneware,
14 ½ in. h. x 7 ¾ in. dia.

Purchase 1996 Mrs. James C. Brady
Fund, Carrie B. F. Fuld Bequest Fund,
Franklin Conklin Memorial Fund and
Eleanor S. Upton Bequest Fund
96.76a,b

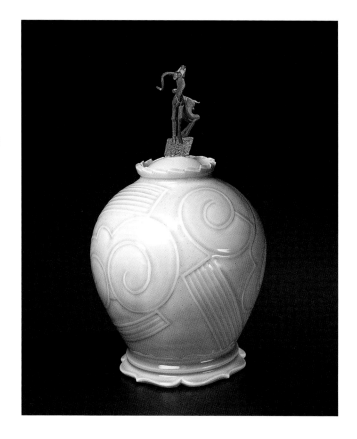

The rise of the studio potter is a phenomenon well represented in the Museum's ceramics
collection. Having begun collecting modern ceramics in 1910, the Decorative Arts
department continues to build its holdings in contemporary ceramic art. This remark-
able vessel was first shown in the Museum's important 2003 exhibition *Great Pots:
Contemporary Ceramics from Function to Fantasy* and was highlighted in the accompa-
nying catalogue.

Saxe's *Antelope Jar* pays wry homage to the elite veneration of porcelain that began
with Marco Polo's first encounter with porcelain in China in the thirteenth century.
Saxe contrasts the vessel's body with an impossibly delicate finial sculpture of an
antelope made of tough, grainy stoneware, the substance of centuries of enduring folk
pottery. The jar celebrates the beauty of Chinese and European porcelains of the eigh-
teenth century with its glaze and ogee-molded foot while simultaneously drawing on
design motifs of the 1960s and 1970s with its Pop Art graphic carving and rim mod-
eled to evoke an industrial gear.

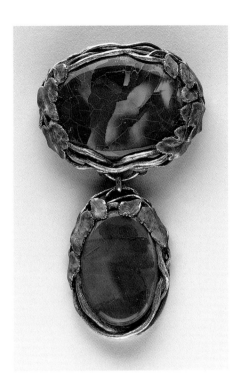

Brooch and pendant, 1915–20
Louis Comfort Tiffany and Meta Overbeck for
Tiffany & Co., New York City

Gold, opals, enamel, 2 ³/₄ x 1 ³/₄ in.

Purchase 2005 Helen McMahon Brady Cutting Fund
2005.7.2a,b

The Newark Museum's expanding jewelry collection includes both production jewelry and one-of-a-kind examples of the jeweler's art. Acquired from the collection of pioneering Tiffany scholar Robert Koch, this jewel was part of the 1958 exhibition at the Museum of American Craft in New York City that was largely responsible for the reevaluation of Tiffany's reputation as a designer.

Tiffany approached his jewelry designs as a painter and a colorist. This splendid brooch capitalizes on the iridescent colors of two massive black opals from Australia. The shimmering surface of the stones evokes the colors of a peacock feather, and Tiffany contrasted those colors with the autumnal oranges and greens of the enameled grapevines that embrace the stones. It was made by Meta Overbeck, who oversaw Tiffany's art jewelry studio on the sixth floor of Tiffany & Co. from 1914 to 1933.

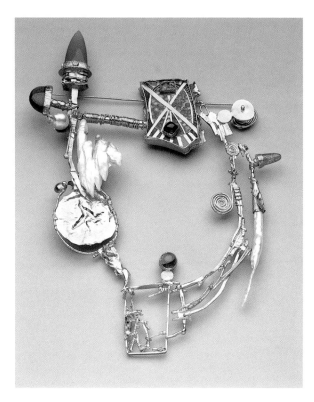

Grand Barbarian's Trapeze and Cask, 1998
William Harper (born 1944; lives and works in New York City)

Gold, enamel, colored gemstones, baroque pearls, 9 ¾ x 7 in. (brooch), 16 ½ x 13 x 7 ¾ in. (case)

Purchase 2000 Membership Endowment Fund 2000.14a,b

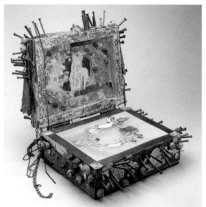

The Newark Museum's historical interest in jewelry is twofold: it reflects the City of Newark's century-long dominance in the American jewelry industry, and it reflects the institution's ongoing commitment to collecting modern craft and design. Bill Harper, one of the most important figures in the field of contemporary jewelry, began to use found objects in the 1960s as an adjunct to his extraordinary skills with metalwork and enameling.

Based on the fibula-type cloak pins of antiquity, this massive brooch is referred to as the *Grand Barbarian's Trapeze*. It combines enamel, baroque pearls and colored semi-precious stones with a Tiffany-like eye for color and organic form. Additionally, Harper has created a "cask" for his barbaric jewel, featuring an antique glass "turtleback" tile from Louis Comfort Tiffany's glass factory. The forest of nails on the exterior of the box refers to both the nail-studded figures from the Congo known as *nkisi nkondi*, and to the artist's affliction with migraine headaches. The interior of the box, which is carved to receive the jewel, is reminiscent of the box constructions of Joseph Cornell.

Folded bowl, 1944
Gertrud and Otto Natzler (Gertrud, 1908–1971; Otto, 1908–2007, lived and worked in Los Angeles)

Stoneware, 13 ¾ x 10 ⅝ x 4 ⅝ in.

Purchase 1949 *49.374*

In 1948 the Newark Museum mounted an exhibition called *The Decorative Arts Today*, which carried on John Cotton Dana's legacy of considering craft and industrial design as equal partners. The focus of the exhibition, from which the Museum purchased this bowl, was on objects that could be used in the modern home.

Gertrud and Otto Natzler fled Nazi Germany in the 1930s, eventually settling in California, where they became leading figures in the contemporary craft movement that burgeoned after the Second World War. Among the greatest examples of 1940s studio pottery in the country, this exquisitely made bowl exemplifies the Natzlers' incomparable technical skill. Its abstract, biomorphic form and complex silky glaze challenge the viewer to look past its functional form and to see a sculpture.

Cobalt Violet Deep Persian Set, 1993
Dale Chihuly (born 1941; lives and works in Seattle, Washington)

Glass, 15 x 31 x 16 in.

Gift of Dena and Ralph Lowenbach, 2007 2007.59.1

Modern glass has been of interest to the Newark Museum since it purchased its first pieces by Lalique in 1913. The rise of studio glass since the 1960s is reflected in the expansion of the Museum's holdings of contemporary glass. In 2007 the Museum celebrated the promised gift of an important local collection of studio glass with the exhibition *The Art of Glass from Gallé to Chihuly: Highlights from the Lowenbach Collection.*

This iconic work by Seattle glass artist Dale Chihuly sums up his use of vivid color and organic abstract forms to create sculptures that are still linked to the vessel tradition in glassblowing. Chihuly was the first American to work in a Venetian glass factory, and was captivated by the techniques of the Murano glass tradition, which he discovered during a Fulbright Scholarship to the Venini factory in 1968. Chihuly's signature glass style has become a global phenomenon, combining art with entrepreneurship.

Sacred Spaces

All cultures create sacred space. The small carved door from central Gabon was a portal to a temple built for initiates of Bwiti, an important social, political and religious institution. The designs on the door refer to central concepts in Bwiti religious thought and mark it as a literal gateway to the attainment of knowledge of cosmic order. Asher B. Durand's luminous landscape was a metaphorical gateway to a sacred space as understood by Americans in the nineteenth century. The golden light infusing the serene natural world depicted in the painting symbolized God's blessing and implied man's special place in the cosmos. To look at the painting was to enter a sacred realm. When the Nepalese lotus-mandala is folded up into a tight

1. **Door for Bwiti temple, late 19th–early 20th century**
 Gabon; Tsogo
 Wood, pigment, metal, 31 ½ x 21 ½ in.
 Purchase 2003 Membership
 Endowment Fund *2003.12*

2. ***A View of Schroon Lake*, 1849**
 Asher B. Durand (1796–1886; lived and worked in New York City)
 Oil on canvas, 30 x 42 in.
 Purchase 1956 Wallace M. Scudder
 Bequest Fund *56.181*

3. **Navadurga lotus-mandala, 16th century**
 Nepal
 Copper-alloy, 5 ⅜ x 6 in.
 Gift of Dr. and Mrs. Richard J. Nalin, 1990 *90.400*

1.

lotus bud, the unseen sacred space within implies divine potential. Opened, the mandala becomes a conduit to a divine realm inhabited by a group of goddesses. Each goddess, originally depicted on one of the mandala's eight petals, is affiliated with a point of the compass that defines a virtual sacred space and determines the sequence of ritual worship. In some cases, when sacred objects are exhibited in a museum, a portion of the museum may also become sacred space. See page 95 for an introduction to the Newark Museum's consecrated Tibetan Buddhist altar.

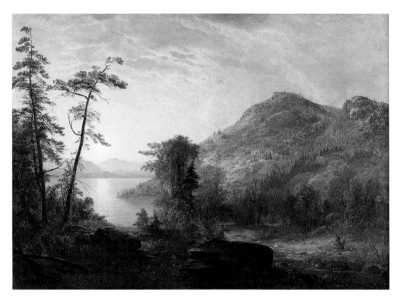

2.

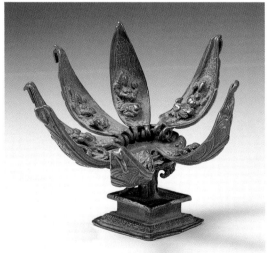

3.

Ancient Art

From the Museum's founding in 1909 until 1924, when Mrs. Samuel Clark gave more than six hundred objects that represent daily life in the ancient world, antiquity in the Newark Museum's collection was represented largely by plaster casts. By 1928 a significant group of ancient ceramics and limestone sculptures from Cyprus had been purchased with funds from founding trustee Louis Bamberger.

The most important single gift of ancient art came in 1950 from the collection of Eugene Schaefer, a New Jersey chemist who amassed nearly two thousand objects between 1910 and the 1920s. Over half of the collection, given by Schaefer's widow, is glass, making Newark's ancient glass collection among the finest in the United States. Dating from 1500 B.C. to 1400 A.D., the Schaefer glass collection offers a visual history of the evolution of glass technology in Egypt, Greece, Rome and the Islamic world.

Founding director John Cotton Dana traveled to Egypt in 1929 and purchased important examples of ancient Egyptian writing. More recent acquisitions illuminate much about Egyptian religious practices with objects such as bronze statuettes and gemstone amulets of deities. Objects of daily life in Egypt, such as a painted boat with oarsmen, a wooden headrest and a bronze mirror, are also represented in the collection. One

of the most treasured objects is the outstanding coffin lid of Henet-Mer, which was purchased by the Museum in 1965. A wide range of funerary objects such as *shabti* (answer figures), amulets and part of a Book of the Dead all aid in our understanding of Egyptian funerary practices.

The Museum's Greek and Roman collections provide a broad overview of ancient life. Beautiful objects from ancient Greece such as a woman's bronze spindle, jewelry and the elegant painted pottery vessels used in symposia, or all-male gatherings, demonstrate Greek ideals of balance and restraint. Fine works of Roman marble sculpture include a funerary stele for Sextus Munatidius, a large and elegant portrait bust of a woman and an important 2001 acquisition of a portrait bust of a young North African man. Drinking cups and plates made from silver, bronze, glass and marble re-create the elegance of the Roman banquet.

Since the 1970s the Museum has endeavored to build a comprehensive picture of late antique Egyptian Coptic art. Superb decorated textiles include an important tunic panel depicting Dionysos and two complete Coptic tunics. Religious items such as a Coptic biblical text and a bronze censer, carved friezes of painted stone and a folding jeweler's balance beam in its original wooden box are also included in the collection. One of the rarest objects is the sixth- to early seventh-century painted funerary portrait of Brother George the Scribe.

Coffin lid of Henet-Mer, Dynasty 21 (1075–945 B.C.)
Thebes, Egypt

Sycamore fig wood, gesso, paint,
73 x 20 x 11 ½ in.

Purchase 1965 John J. O'Neill Bequest
Fund 65.65

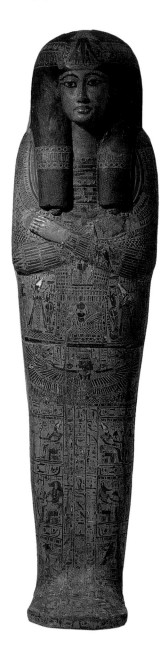

Henet-Mer lived at Thebes, the capital of southern Egypt, three thousand years ago. She was "Mistress of the House," a married woman and "Chantress of Amun," as the hieroglyphs on the legs of the coffin inform us. She was one of a respected group of women who chanted prayers before the images in the temple of Amun, the principal deity of Thebes. Her face is not a literal portrait, but rather an ideal of ancient Egyptian feminine beauty, depicted with eye paint and a wig adorned with a lotus flower, the symbol of rebirth. Her coffin was fitted together from many pieces of wood, gessoed, painted and then varnished to achieve a more golden color.

The coffin scenes depict protective funerary deities such as Nut, the sky goddess, with her outspread wings, and the scarab beetle, symbol of resurrection. Small panels along the sides show Henet-Mer awaiting judgment before the gods of the underworld, chief among them Osiris, king of the dead, in his white crown. Other deities pictured include the hawk of Horus and the ram of Amun. Some time after her death, Henet-Mer's coffin and grave goods were moved along with other burials to an older tomb for safekeeping. Unfortunately, because grave robbers looted this tomb, Henet-Mer's mummy has not survived.

Limestone statue of a votary, 450–425 B.C.
Golgoi or Idalion, Cyprus

Limestone, paint, 39 x 11 x 4 ½ in.

Gift of Louis Bamberger, 1928 *28.208*

This is the first large-scale stone sculpture to enter the Newark Museum's collection of ancient art. It is carved of limestone, with traces of red paint still visible. Sculptures in antiquity were not white, as most appear now, but rather quite colorful, with painted patterns on clothing, facial features accented with color and even gilding on hair and jewelry. This sculpture was made on the island of Cyprus, located in the eastern part of the Mediterranean. Cypriot art reflects its position between the Near East and Greece.

Unlike Greek sculpture of the time, this figure of a young man was meant to be seen only from the front and therefore the back is flat. He wears a long tunic and shoes, with a wreath on his head. In his right hand he carries a dove as an offering to Aphrodite, the patron goddess of Cyprus, while his left hand originally held a small incense box. Statues such as this stood in temple sanctuaries, acting as constant worshippers for their wealthy donors.

In the 1870s Colonel Luigi de Palma Cesnola, American consul to Cyprus, sold 35,000 objects from his excavations in Cyprus to The Metropolitan Museum of Art in New York. This statue and the rest of our small, choice Cypriot collection were acquired as the Metropolitan sold or auctioned some of these holdings in the 1920s.

Amphora for oil or wine, ca. 530 B.C.
Manner of the Antimenes Painter
Athens, Greece

Ceramic, 14 ½ in. h. x 9 in. dia.

Eugene Schaefer Collection, Gift of
Mrs. Eugene Schaefer, 1950 *50.277*

One of the most enduring figures of classical mythology was the flawed hero and strongman Herakles, the Roman Hercules. As atonement for committing a terrible murder, Herakles was forced to perform twelve seemingly impossible labors for the wicked King Eurystheus. The front of this vase depicts the first labor of Herakles, the killing of the lion of Nemaea. Since arrows could not pierce its hide, Herakles uses his superhuman strength to strangle the beast. The goddess Athena and his faithful nephew Iolaos stand by to help. Herakles' useless quiver, arrows and club are shown. Fine tableware such as this amphora were made for symposia, social gatherings for male Athenians. A strong, never-defeated Herakles was the perfect subject for symposium tableware.

Craftsmen used the potter's wheel to form this vase from the fine clay found near Athens, and shaved it down to achieve precisely balanced contours. They used two different natural pigments that changed color from black to orange depending on the reduction and oxidization cycles in the kiln. Red accents and incised lines further enliven the figures. The harmonious outline of this vase, and the precise placement and balance of figures and ornament, reflect ancient Greek ideals of beauty.

Pomegranate-shaped vase, 12th century B.C.
Egypt

Core-formed glass, 3 ¾ in. h. x 3 ¾ in dia.

Eugene Schaefer Collection, Gift of
Mrs. Eugene Schaefer, 1950 *50.1249*

True glass came to Egypt about 1550 B.C., probably first made by Near Eastern arti-sans who were brought to Egypt as a result of conquests. Glass is made of sand, soda and lime, which are melted at high temperatures and worked while still molten. Metal oxides are added for color—for example, copper for blue and lead for yellow. This material, which was very difficult to make with ancient technology, was rare and valued as highly as gemstones. A luxury item, glass was made in workshops associated with the Egyptian royal palaces.

Vases such as this one were made by the "core forming" technique, in which the desired form was shaped in a core of clay and animal dung on a metal rod, and then wrapped with threads of molten glass—first the blue base color, then yellow and white—which were combed up with a sharp implement to produce the feathered patterns. The shape imitates a pomegranate, a fruit imported from the Mediterranean. The unusually large size and square-shouldered form make this vase unique, though smaller pomegranate-shaped glasses were made both in Egypt and Cyprus.

Ennion cup, ca. 40–50 A.D.
Sidon, Rome

Mold-blown glass, 4 7/8 x 2 3/8 x 3 3/8 in.

Eugene Schaefer Collection, Gift of Mrs. Eugene
Schaefer, 1950 *50.1443*

This delicate and elegant cup is one of the rarest and most highly
regarded glass objects in the Newark Museum's collection. Most
ancient artisans are anonymous, yet the nameplate on this glass
proudly proclaims "Ennion made me." Since he signed as both
engraver and glassblower, it is believed that Ennion may have actu-
ally invented the difficult process of blowing molten glass into a
multipart engraved metal mold. While his designs imitate expensive
one-of-a-kind silver vessels, the mold-blowing process made it possible
to turn out multiple copies of a single design.

Ennion may have been one of a group of skilled glassmakers
who worked in Sidon (now Lebanon) in the first century A.D. It is
known that five such masters signed their work, but none were as
skilled as Ennion. He made drinking vessels like this one in a variety
of designs and colors, as well as large, elegant jugs and hexagonal
vases. A number of Ennion's cups have been found in northern
Italy, leading some to believe that he moved his workshop there.
However, signed Ennion vases and fragments have been found from
Spain to the Black Sea, making it more likely that he shipped his
pieces widely around the Mediterranean.

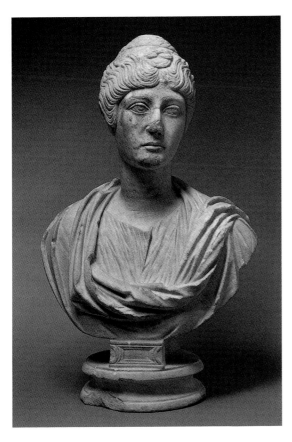

Portrait bust of a lady, ca. 150 A.D.
Roman, Asia Minor

Marble, 25 ½ x 15 ¼ x 8 ⅝ in.

Purchase 1971 Charles W. Engelhard Bequest
Fund 71.79

The Romans had a long tradition of displaying life masks of ancestors in their homes. Sculpture in marble first came to Rome in the second century B.C. as plunder from their conquests of Greek cities. In Rome, early marble portraits were sometimes harshly realistic, but when this likeness was carved, around 150 A.D., there was a trend toward more flattering idealism, especially in depictions of women.

The size and quality of this bust shows that the subject was an upper-class woman. We can date her portrait from her hairstyle. The elaborate coiffure, with long braids of hair piled in a crown on top of the head, copies the hairstyle of the revered empress Faustina the Elder, wife of the emperor Antoninus Pius. Portraits of the emperors and empresses on coins circulated throughout the empire, and their official likenesses were copied and displayed in every important town and city.

This lady's portrait may have been dedicated in a temple, placed in a tomb or set up to commemorate benefactions to her city. While Roman women were not allowed to hold public office, they could use their own wealth and property to donate buildings and fund charities. Some portraits of older women show a steely toughness of character, but the smooth surfaces of this likeness give no hint of the personality within.

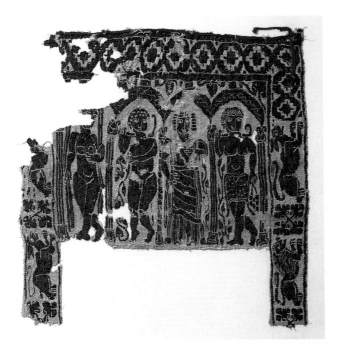

Neck and chest decoration from a tunic, 6th century A.D.
Egypt

Linen, wool, 7 ⅞ x 14 ⅛ in.

Purchase 1983 Mathilde Oestrich Bequest Fund *83.43*

By the third century, the Egyptians had stopped mummifying their dead and wrapping them in yards of torn linen. Instead they laid the bodies, dressed in layers of their own clothing padded with discarded household textiles, in shallow graves or in mausoleums. The basic item of dress was the slit-neck tunic, generally of linen, sometimes of wool. Weavers wove the linen on very wide looms in one piece from front to back hem. As work progressed, skilled weavers worked woolen threads into the linen warp at intervals to create complex figural, geometric and ornamental designs. Patterns were the same on the front and the back.

One popular subject was the god Dionysos, patron deity of wine and ecstatic revelry, who promised immortality to his followers. In this panel from just below the neckline is a woven Dionysiac design that was thought to promote good luck and long life for the tunic's wearer. In the center, framed under arches, stand Dionysos and his wife Ariadne, flanked by a dancing female Maenad and a satyr in an animal-skin kilt. Hares, lions and stylized vine leaves form the vertical bands that continue down to the hem of the garment.

Brother George the Scribe,
6th–early 7th century A.D.
Monastery at Bawit, Egypt

Sycamore fig wood, tempera paint, 11 ½ x 15 ¾ in.

Purchase 1983 The Members' Fund *83.42*

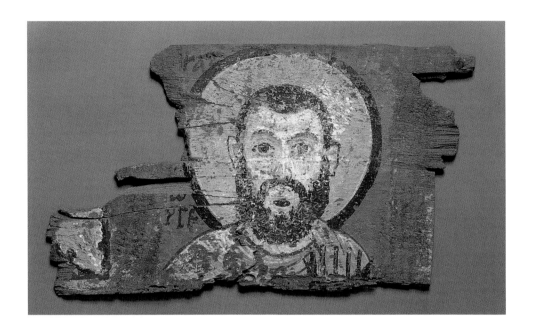

The inscription to the right of the halo identifies this monk as Brother George the Scribe. Painted with strong outlines and simplified forms, Brother George gazes out at eternity. Four pens, the tools of his profession, are held in a leather pen case slung over his left shoulder. Details such as the gray shading at the eyes and along the side of the nose are now obscured by loss of paint. While gray paint is similarly used on the famous Coptic icon of St. Menas, it should be noted that this is not an icon, but rather a funerary portrait, the halo indicating that Brother George was revered among the deceased.

Two portraits very similar to this one were found during the excavations of 1900–12 at the Bawit monastery in Egypt. Although quite stylized, all three represent clearly different, recognizable people, and one, "Brother Mark," seems to have been painted by the same artist who painted Brother George. There are two reserved vertical panels on each side of the portrait, perhaps for strips to attach it to a wall. The fragment of a four-petal design on the far right of the panel suggests a divider between Brother George's portrait and another one. These portraits served as remembrances of the deceased that were on view during communal prayers.

More than Money

Since antiquity, money has always held significance greater than its value as currency. The Museum's extensive collection of coins and paper money represents thousands of years of human history and culture. Julius Caesar (100 B.C.–44 B.C.) had a silver denarius minted in Africa both to mark the defeat of an opponent and to invoke the mythical fall of Troy, associating Caesar with the heroes of ancient Greece. The large gold coins produced in New World mints for Spanish ruler Philip V (1683–1746) were designed to

1. **Denarius of Julius Caesar,
 50–40 B.C.**
 Roman Africa
 Silver, ³/₄ in. dia.
 Gift of Mark and Lotte Salton in
 Memory of Felix Schlessinger, 1993
 93.163.125

2. **Eight-escudo coin of Philip V, 1712**
 Peru
 Gold, 1 ³/₈ in. dia.
 The C. Bremner H. Jackson Coin
 Collection Gift, 1993 *93.162.552*

3. **Ten-ryo oban of Emperor Komei,
 1860–61**
 Japan
 Gold, ink, 5 ¹/₄ x 3 ⅞ in.
 Gift of Frank I. Liveright, 1925
 25.1397.290

4. **Twenty-dollar coin, 1907**
 Augustus Saint-Gaudens
 (1848–1907; lived and worked in
 Cornish, New Hampshire, and
 New York City)
 Gold, 1 ¹/₄ in. dia.
 Gift of Frank I. Liveright, 1925 *25.1397.257*

5. **Fifty-dollar commemorative coin,
 1915**
 Robert Ingersoll Aitken
 (1878–1949; lived and worked in
 New York City)
 Struck at United States Mint,
 San Francisco
 Gold, 1 ³/₄ in. dia.
 Purchase 1983 Newark Museum Coin
 Fund *83.534.1*

1.

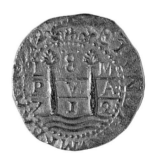

2.

assert his court's wealth and prestige in North, South and Central America in the eighteenth century. In Japan, the first coins were large thin ovals called *oban*, used from the 1500s to 1860 for banking transactions. Bearing stamps and fragile ink signatures to foil forgers, gold *oban* were also especially prestigious rewards given by the nobility. Since the Renaissance, coins have also been appreciated for their aesthetic value. Famed American sculptor Augustus Saint-Gaudens was commissioned to design his celebrated "double eagle" in 1907, while Robert Ingersoll Aitken, inspired by ancient Greece, designed a substantial fifty-dollar coin to commemorate the Panama-Pacific Exposition in San Francisco in 1915.

4.

3.

5.

Education at the Newark Museum

*The museum that helps a teacher to make her lessons easier for herself and
more interesting and more instructive to pupils, and that does this constantly,
day in and day out, and on every subject in the curriculum—that is the only
museum worth speaking of in the same breath with schools.*
 – J. C. Dana, 1918

When John Cotton Dana began to formulate his ideas for a "new museum" in the
early twentieth century he emphasized its utilitarian role: to educate the then
largely immigrant and working-class population of Newark. This philosophy was
emblematic of the Progressive Era's response to powerful changes in society.
Accordingly, Dana designed a museum that would enable visitors to use art and
science collections to find meaning in their own lives. This commitment to rele-
vance and to teaching and learning with objects continues today, as the Newark
Museum annually allocates a higher percentage of its operating budget to educa-
tional programming than do most other major American museums.

Apprentice class, 1925–26

Dana was assisted in his efforts by Louise Connolly (1862–1927), an experienced public school educator. In 1912, when Dana instructed Connolly to study how other museums defined education, she found only a few examples to admire. She strongly recommended that the collections and related programs should connect to people's lives and be accessible, both intellectually and physically. In contrast to most other museums at the time, which were considered "elitist," the Newark Museum's approach, with its strong mission to serve all of the community, was revolutionary and set the standard for museum education for years to come.

One of the most significant ways in which Dana made museum objects accessible to the broader community was the establishment of the Lending Department in 1912 (see page 158). This department, now known as the Educational Loan Collection, literally takes the Museum beyond its walls. Closely related to the Lending Department was the Branch Museums program, which featured temporary exhibits installed in regional libraries, schools and storefronts.

In 1913 Dana pioneered the creation of the Junior Museum to engage young visitors in exhibits, after-school programs, special weekend events, year-round classes and summer camps. This has evolved into the Junior Museum Studio Program and includes Saturday classes for two- to fifteen-year-olds, Camp Junior Museum, a six-week summer camp for children ages three to fifteen, and Science Explorers, an in-depth apprenticeship program for teens that teaches

Victoria Hall of Science

job preparedness skills. In addition, the Junior Gallery, established in 1929, continues to employ real objects to inspire and educate young people and their families through the presentation of youth-oriented exhibits. Recent exhibits have included *Stepping Into Ancient Egypt: The House of the Artist Pashed* (1991), *Explore Korea: Grandfather's House* (1995) and *Once Upon a Dime: The World of Money* (2003 and 2008). The Mini Zoo began as the Junior Museum Nature Corner in 1930 and still utilizes live animals in science instruction for youth and families (see page 157).

Dana was especially interested in meeting the needs of new immigrant groups and in 1916 introduced a series of "Homelands" exhibitions. Children would bring objects representing their cultural roots to be displayed first in their schools and then at the Museum—exhibits he widely publicized in an effort to draw in new Americans.

Always responsive to social change, the Museum established the Arts Workshop in the 1930s to provide instruction for the growing numbers of unemployed adults. At first these were mostly "hobby" programs, but by 1937 the focus changed to more organized classes with formal instruction.

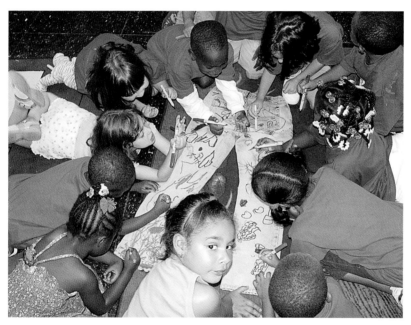

Junior Museum Workshop

Discontinued at the start of World War II, the classes were reintroduced in 1945 and participants could enroll in more than ten different programs, including weaving, clay, sculpture and painting. Workshops grew in popularity and now feature a wide range of courses taught by leading local artists and premier artisans, reflecting current trends in enameling, jewelry-making, pottery and glass, painting, sculpture, fiber arts, photography and book arts.

Since its founding, the Museum has had a commitment to serve the needs and interests of the schools. Dana encouraged "visual instruction" and hands-on discovery methods in the Museum and in the schools. Docent-led tours of the Museum were provided for schools, and teachers were invited to attend workshops where they could develop new curricula that incorporated art and

science collections. Today, tours for students in preschool through high school address curriculum content standards for visual art, science, social studies and language arts. Professional development workshops for school teachers and administrators emphasize the value of object-based teaching. Services to schools have also expanded through videoconferencing, on-line curriculum resources, artists in residence and outreach science workshops for students.

The Museum also continues to provide a wide variety of public programs and educational services in art and science—lectures, films, performances, tours, festivals, symposia and more. Today, drop-in workshops for families, special programs for senior adults, an art history series and presentations by leaders in the world of science encourage the community to view the Museum as a center for learning. Two popular, long-running programs of note are the annual *Jazz in the Garden* concert series, started in 1965, and the *Newark Black Film Festival*, started in 1976. Hundreds fill the garden for the concerts each week to enjoy performances of prominent jazz musicians and vocalists; and the festival, the longest running of its kind, has become one of the nation's defining voices of independent film and the black experience.

As the Newark Museum celebrates its centennial, it continues to be a model of invention and innovation for twenty-first century museum educators and a sustaining resource for its large and appreciative community.

Jazz in the Garden

Victoria Hall of Science

Dynamic Earth: Revealing Nature's Secrets, the featured exhibition of the Victoria Hall of Science, showcases more than four hundred spectacular specimens from the Museum's Natural Science Collection in an immersive environment with interactive multimedia presentations, video games, "hands-on" discovery panels and participatory demonstrations.

This unique combination of real objects and the latest in exhibition design illustrates 4.6 million years of Earth's geological change through the process of plate tectonics (continental drift), the resulting creation of biomes (habitats) and the adaptation of plants and animals to new conditions (evolution).

Six permanent galleries as well as the Prudential Foundation Gallery for changing exhibitions were designed by Museum science educators and exhibition experts to appeal to the interests of families and school groups. Visitors learn about geological forces and visualize the Earth's changing geography. Panoramic dioramas illustrate the adaptations of plants and animals to newly formed biomes such as the African savanna, Arctic tundra and a tropical rain forest. Interactive games test players' knowledge and teach the concept of natural selection. The New Jersey Highlands biome, formed through 1.2 billion years of geological history, is re-created in the exhibit to teach science concepts such as water, rock and carbon cycles.

A highlight of *Dynamic Earth* is the remarkable, true-to-life re-creation of a limestone and marble cave revealing New Jersey's geological history as a land mass first formed in the southern hemisphere that migrated to its present position.

Visitors explore bats, cave formations and fluorescent minerals unique to New Jersey and take rubbings of million-year-old fossil replicas. Changing exhibits take place in the adjoining Prudential Gallery. *Dynamic Earth* concludes in a tented "field station" in which visitors of every age may make their own scientific discoveries.

The Natural Science Collection was initially developed by Newark physician Dr. William S. Disbrow (1861–1922), a gifted naturalist who enthusiastically tackled his avocation—collecting, mounting and identifying natural objects. He first displayed his

biological and geological treasures in 1905 with the intent to educate the public about the marvels of the natural world. Disbrow's bequest of 74,000 specimens included minerals, rocks, gems, fossils, shells, corals, sponges and pressed plants. His economic botany collection of fibers, gums and resins, fruits and seeds of importance to agriculture or as raw materials reflected the commonly held perception of the natural world as an agricultural and commercial resource.

The collection has grown to more than 83,000 specimens, including nearly 10,000 important taxidermic birds, study skins, bird eggs and nests donated between 1930 and 1960. Colonel Anthony R. Kuser donated an impressive selection of twenty-five Asian pheasants from explorer William Beebe's 1909–11 expeditions to India and China, which Kuser had sponsored. Charles Rummel's insect collection showcased early twentieth-century insect fauna of New Jersey and neighboring states. Collections such as these are now critically important in assessing changing patterns of biodiversity over time. Examples of extinct or endangered and threatened species of birds, insects and shells include the rare eastern North American Carolina Parakeet, *Conuropsis carolinensis* (Lesson, 1831), and Passenger Pigeon, *Ectopistes migratorius* (Linnaeus, 1766). Trophy heads and Victorian domed mounts are reminders of an era when specimen collecting was a popular pastime.

The collection supports a lively schedule of exhibitions, research projects and student internships, illustrating the changing nature of specimen collecting over time, from Dana's and Disbrow's early enthusiasm for linking observations of art and natural science to our current ecological and animal rights awareness.

Scarlet Ibis
Eudocimus ruber (Linnaeus, 1758)
South America
Donated by the family of James E. Bathgate
OR 034.16

These striking wading birds are covered with bright red feathers and black wing tip highlights. Their long necks and curving bills enable them to probe shallow waters of interior or coastal wetlands, where they feed on crustaceans, insects and small fish. While juveniles start out dull gray in color, with a constant diet of red crabs or shrimp, both male and female adults eventually acquire bright scarlet plumage. Scarlet ibises are colonial species; they fly, breed and nest together and their large numbers create an effective predator defense. Since the sixteenth century, feathers from these beautiful creatures have been prized for adornment. Now, over-hunting, disruption of their habitat and pollution of both air and water seriously threaten the survival of this ancient species.

Fossil Fish
Eocene Period
Green River Canyon, Colorado
Donated by J. Ferdinand and H. F. Herpers *P 27.2*

These fossil fish date back about forty-eight million years, to the Eocene Period when the Green River Formation was a series of lakes stretching across Wyoming, Utah and Colorado. It is believed that the low temperatures and depth of these lakes helped to preserve such specimens with minimal deterioration, as the area is well known for its rich trove of bony fish fossils. Fine sediment deposits captured the extraordinary details of fossil anatomy not only for fish but also for other vertebrates, invertebrates and plants. The Eocene Period marks the disappearance of large reptiles and the emergence of mammals. Studying fossils from this period helps scientists understand the dramatic evolutionary process that occurred during this time.

In Latin, the common name *longimanus* refers to the extremely long forelegs of the male Harlequin Beetle, which are longer than their entire body. These odd-looking legs are thought to enable the insects to traverse tree branches more easily. Scientists believe that they may also serve as a sexual lure to females or as a deterrent to other males. The dazzling green and dark-reddish patterns on the insect's body provide effective camouflage among the lichen- and fungus-covered tree trunks in the tropical forests of South America. Amazonian native peoples have long been inspired by the ornate patterns and colors of these beetles and have imitated them on their shields.

Harlequin Beetle
Acrocinus longimanus (Linnaeus, 1758)
Female
Colopaxi, Reserva Otonga
Ecuador, 2000
Collected by Sule Oygur *Z 2000.1*

The mineral gypsum is found in sedimentary rock composed of 79.1% calcium sulphate and 20.9% water. Gypsum deposits formed millions of years ago as the receding oceans that covered the earth dried and precipitated the mineral. The sculpturelike form seen in this specimen was probably produced by a slow evaporation process. The water in gypsum is referred to by geochemists as "water of crystallization": while the mineral is perfectly dry to the touch, the water within releases as vapor when exposed to temperatures of 212°F or above. This makes gypsum an effective fire-retardant material, used in the contemporary construction industry as the primary component of sheetrock or "drywall."

Gypsum Mineral
Fish-tail specimen
Donated by Richard Hauck *M 746.127*

Alice and Leonard Dreyfuss Planetarium

The Alice and Leonard Dreyfuss Planetarium opened in 1953 as New Jersey's first planetarium. Over the ensuing decades its programs have thrilled and educated more than 1.5 million people, from junior astronomers to senior stargazers.

The wonders of the universe are revealed through innovative programs, traditional star shows and related exhibitions. Under the Dreyfuss dome visitors shared the excitement of the space race of the 1960s and 1970s and the historic *Apollo 11* lunar landing in 1969. More recently the Dreyfuss Planetarium has popularized space exploration to other planets and their moons by the *Voyager, Galileo* and *Cassini* spacecraft, as well as the extragalactic discoveries of the Hubble Space Telescope and the manned missions of the Skylab and Space Shuttle programs.

In 1927 Museum founder John Cotton Dana envisioned a 500-seat star theater that would have been the nation's first had it been built. His dream was not realized until the 1953 gift of New Jersey philanthropist and Museum trustee Leonard Dreyfuss and his wife, Alice. Fulfilling Dana's wish that it be an important educational tool, the planetarium was quickly established as a leader among facilities of its size, receiving early recognition for creativity and programmatic excellence.

The "stellar" optics of the planetarium's state-of-the-art Zeiss ZKP3B projector, which can project up to 7,000 stars and display the correct positions of the sun, moon and planets, enable audiences to enjoy seasonal shows of the constellations. Added audiovisual and special effects explore not only the science of the stars but the myths and cultural practices inspired by them. Younger visitors are introduced to basic concepts of astronomy, while older children and adults are presented with more complex astronomical phenomena. The Planetarium Gallery features small interactive exhibits on a variety of space-related topics.

In 1985 the Dreyfuss Planetarium was one of the first to provide educational outreach through a portable planetarium. The newest "Skylab" combines digital technology with an inflatable dome to bring the stars "down to earth" so that students may study the cosmos in a familiar school-based learning environment. The planetarium extends its educational outreach through a state-of-the-art weather station, updated Sky Watch information and other key astronomy links.

Mini Zoo

Live animals have been part of the Newark Museum's science program since the 1930s, when they were first introduced into the Nature Corner of the Junior Museum. An increasing number of mammals and reptiles were incorporated into the Museum's educational programming and began to be permanently housed there. This "living collection" resulted in the creation of today's Mini Zoo. As part of the Museum's 1989 master plan, the Mini Zoo was rebuilt with consideration given to appropriate species for animal enclosures and evolving animal welfare standards.

The Mini Zoo today is home to more than one hundred live animals, representing forty-one exotic species of fish, invertebrates, reptiles, mammals and birds. Seventeen indoor exhibits feature small animals native to habitats throughout the world. Among the Mini Zoo residents are silkie chickens, marmosets (shown here), a sugar glider, screech owls, a fennec fox, a legless lizard and a blue-tongued skink. While the majority of these animals have been acquired through zoological society breeding programs, sometimes of endangered species, others are rehabilitated animals injured in the wild and unable to survive in their natural habitats. The Mini Zoo's professional animal keepers ensure that they receive the finest veterinary, nutritional and behavioral care.

One of the Mini Zoo's primary objectives is to connect people to nature through inquiry-based, hands-on learning experiences. Programs such as "Fish Tails," "Great Adaptations" and "Habitat Harmony" cover topics including adaptation, evolution, ecosystems, the food web, conservation, classification of animals and animal behavior. "Art to Zoo" links live animals to animals in art. As part of its outreach programs, Mini Zoo educators bring animals to local classrooms to teach children about animal behavior and care.

Delightful and engaging, the Mini Zoo is equally an important aspect of the Museum's educational program and one of the most popular destinations for visitors, especially families and children.

Educational Loan Collection

By the time he became the Museum's founding director, John Cotton Dana was well known for his progressive theories on increasing public access to recorded knowledge. One of his earliest attempts to increase the utility of museums was to apply the lending practice of libraries, so that borrowing cultural objects and artifacts could be as easy as borrowing books from the shelves of a library. Beginning in 1912, the Newark Museum Lending Department became a public resource for museum-quality art and science objects. As Dana collected objects for the permanent collections of the newly established museum, he simultaneously collected authentic specimens representing world cultures, everyday life and science and industry for his unique lending collection.

Today's Educational Loan Collection houses 15,000 objects in categories encompassing Africa, South and Central America, Native Americas, New Jersey, South Asia, U.S. History, Ancient Civilizations, Mexico, Life, Earth and Space Sciences, Eastern and Western Europe and World Religions. These three-dimensional objects—architectural models, costume dolls, rocks and minerals, natural history specimens, photographs, pottery and textiles—have become essential learning aids in classrooms, related to New Jersey Core Curriculum Content Standards common to the state's 552 school districts in the subject areas of art, social studies, U.S. and world history and the natural and physical sciences. Loans are accompanied by teacher resource activity guides and media materials that integrate teaching with objects into classroom curricula.

On any given day, Educational Loan Collection staff might send off to a primary school classroom, a township library or the site of a corporate diversity initiative such objects as a 2,000-year-old Egyptian cat mummy; a model of a medieval castle or an Eskimo igloo; international and domestic flags; nature-study materials such as birds, butterflies and minerals; or even a Native American peace pipe.

The collection's enduring popularity has made it one of the Museum's busiest departments, serving close to 200,000 annual viewers. The staff also curates small traveling exhibits on such subjects as Chinese culture, African musical traditions, Ghanaian *kente* cloth and Latino carnival festivals for regional schools, libraries and businesses, continuing a Dana practice. Few museums established such collections and fewer continue to maintain them, making this a rare cultural and educational resource with an important mission: introducing world cultures, enhancing interdisciplinary studies and developing cross-curricular connections. As Dana noted, the Educational Loan Collection "makes of every schoolroom to which material goes a branch of the museum and every teacher who uses them an admirable docent."

Alice Ransom Dreyfuss Memorial Garden

From the time the Newark Museum's main building was constructed on the site of the former estate of Marcus L. Ward, founder John Cotton Dana began planning for a garden, or as he called it, "an outdoor museum," on the empty, neglected parcel of land immediately behind the building. Dana envisioned the garden not only as a place of beauty and reflection, but also as a space for the hands-on study of botany and the natural sciences.

Once the garden was cultivated and planted with grass and trees along with grapevines and berry bushes, and a Junior Garden was populated with "useful grasses, clover, the cereals, corn and vegetables, as well as many kinds of old fashion flowers," Museum staff began conducting nature walks, *plein air* sketching and painting classes and informal talks on a variety of topics including New Jersey flora. Over the years, generous supporters donated gifts of trees and plantings in much the same way collectors donate works of art.

From the beginning, the garden was also used as an outdoor gallery installed with marble statues by nineteenth-century sculptors such as Thomas Crawford and Chauncey B. Ives. Today, it still serves this purpose, and is now graced with the work of more modern masters including David Smith, Robert Lobe, Joel Perlman, Tony Smith and others. For more than forty years, outdoor summer concerts in the Museum's popular *Jazz in the Garden* series have drawn crowds to hear world-class musicians and enjoy the garden's natural beauty. Many other Museum-sponsored events take place there and it is also visited and enjoyed by local businesspeople, children on field trips, summer camp groups and families. Today the garden, often referred to as "Newark's backyard," still lives up to Dana's original conception of an outdoor space that would be much like the Museum itself—an informal, educational and welcoming place "for the citizens of Newark to visit and enjoy."

Former Museum trustee Thelma Tipson Dear, a lifelong gardener and noted herbalist, was instrumental in a new vision for and restoration of the garden in 1991. The restored space was named in honor of her mother, Alice Ransom Dreyfuss, also a renowned gardener.

Newark Fire Museum

The Newark Fire Museum, a joint project of the Newark Museum and the Newark Fire Department Historical Association, displays a collection of period fire apparatus, memorabilia and historical documents and teaches important fire safety lessons for visitors of all ages.

The Fire Museum is located in a circa 1860 carriage house, once part of the estate of New Jersey governor Marcus L. Ward (1812–1884). The building now stands prominently in the Alice Ransom Dreyfuss Memorial Garden. Two main exhibitions in the Fire Museum cover the history of firefighting as well as fire safety and prevention. Drawn from the archives of the Historical Association and the Museum, *A Cry of Fire: The New Jersey Fire Story* tells the story of the challenges faced by both city dwellers and firefighters in the nineteenth century, when Newark, a virtual tinderbox of wooden houses, was called the "City of Flames." The Newark Fire Department is among the oldest professional corps in the country. Among the nine-

teenth- and twentieth-century fire apparatus and equipment on view is an 1857 hose cart (shown here). The Watch Room Discovery Center helps young people learn the science of fire; by playing a rookie firefighter training computer game they can also learn the requirements to become a firefighter.

The Healthcare Foundation of New Jersey Presents "Fire Escapes: Danger & Survival" is an exciting new exhibit that promotes fire safety and prevention through interactive displays. After a journey through the Hazard House, a replica of a burned-out dwelling, visitors will have learned ways to minimize fire hazards within their homes as well as, in the event of a fire, the necessary steps to take in order to escape it unharmed. Children can also try on kid-size bunker gear, climb into the cab of a decommissioned Newark fire truck, turn on the lights and listen to firefighters respond on a real fire department radio.

Old Stone Schoolhouse

The 1784 Old Stone Schoolhouse was moved, stone by stone, to the Newark Museum's Alice Ransom Dreyfuss Memorial Garden in 1938 with the assistance of the Works Progress Administration.

The schoolhouse originally stood on Pot Pie Lane (so named because the local housewives excelled at making chicken pot pie) in Lyons Farms, renamed Chancellor Avenue, near present-day Weequahic Park in Newark. The red sandstone building was not only the educational center of its Revolutionary-era community but also a religious, social and political meeting place. George Washington is said to have stopped by the site twice, "to address briefly the pupils and their elders, urging them to stand fast in conflict." This small school was known for its high standards of scholarship and it is reputed that "within these modest walls many of New Jersey's leaders received their early training." Here local farm children learned lessons in arithmetic, English, history and science with all grades together in the same room.

In 2005 a restoration, undertaken under the guidance of historic preservationists, uncovered a time capsule from 1938 that had been placed in a cornerstone of the foundation. It contained period schoolbooks, newspapers, teacher salary forms and student report cards, which are now on view. Today, the schoolhouse is set up much the way it was two hundred years ago with tables and benches and a teacher's desk piled high with slates and quill pens. A popular destination at the Museum, it is enjoyed by school groups, families and museum visitors eager to understand what it was like to attend school in the eighteenth century.

Ballantine House

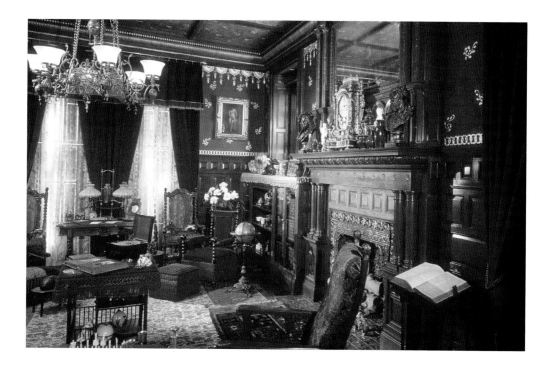

Among the Museum's most popular attractions, the Ballantine House was built for beer brewer John Holme Ballantine and his wife Jeannette in 1885. The Museum purchased the house and its extensive rear addition in 1937. It served as office space for nearly four decades, surviving threats of demolition in the late 1930s and again in the 1960s, eras when Victorian architecture was not appreciated. The Ballantine House was restored as part of the Museum's celebration of the U.S. bicentennial in 1976, with support from the City of Newark.

Retaining all of its original woodwork, fireplaces and stained glass, including an important early Tiffany window, the house has become the centerpiece of the Museum's Decorative Arts collection, and was named a National Historic Landmark by the U.S. Department of the Interior in 1985, the first designation of its kind in the City of Newark. It is one of the few urban mansions on the East Coast that has been fully restored and interpreted for the public, and has become a national icon for the revival of interest in Victorian design and domestic life.

In 1994, with substantial grants from the Lila Wallace Reader's Digest Fund Museum Collections Accessibility Initiative, the National Endowment for the Humanities, the National Endowment for the Arts, the New Jersey Historic Trust and the City of Newark, the Museum began the restoration of the upper floors of the house and replaced aging infrastructure. The dramatic *House & Home* reinterpretation explores the meaning of hundreds of objects from table settings to lighting fixtures, examining why and how such examples of the "decorative arts" were chosen for use in American homes over many years. Even after fifteen years, the exhibition continues to offer an interpretive experience unsurpassed in the nation.

The Ballantine House, itself accessioned as an object in the Museum's collection, continues to serve as a case study of what one family considered an ideal home at the height of the Gilded Age in America, and also how the concepts of house and home are universal.

PHOTOGRAPHY CREDITS

James Mathieu Andres: 12, 56, 108, 109, 160, 162; Armen: front flap, 17, 36, 50, 85, 86, 92, 104, 146, 147; Axis Gallery, New York: 77; Steven Brooke: 13; David Caras: 123; Pat Faison: 45, 137, 151, 163; Jeremy Frechette: 156; Richard Goodbody: cover, 14, 15, 18, 20–25, 28, 33–35, 37–40, 42, 43, 47, 49, 52–55, 57–60, 63–65, 67–70, 72, 73, 75, 78, 79, 88–91, 93, 94, 97–102, 105–107, 110, 116, 117, 124, 125, 128–30, 132–34, 136, 138, 139, 141, 142, 144, 165; Dwight Hiscano: 158; Peter Jacobs: 26, 31; Koenig Studios: 6, 7, 148; Shelly Kusnetz: 149, 150, 159; Myron Miller: 122; Newark Evening News: 9; Kira Perov: 41; John Bigelow Taylor: 82, 87; Jerry Thompson: back flap; William Wagner: 138; Sarah Wells: 19, 27, 29, 32, 46, 48, 54, 55, 61, 71, 111, 112, 126, 140, 143; Stephen White: 76; Joe Zugcic: 154, 155. Other contributing photographers include Olivia Arnone and Susan Petroulas.

COPYRIGHT CREDITS

The Museum has made every effort to trace and contact the copyright holders of the illustrations reproduced in this book; any errors or omissions will be corrected in subsequent editions.

George Segal, *The Parking Garage*, 1968. © The George and Helen Segal Foundation/Licensed by VAGA, New York, NY; Wayne Thiebaud, *Wedding Cake*, 1962. © Wayne Thiebaud/Licensed by VAGA, New York, NY; Georgia O'Keeffe, *Purple Petunias*, 1925. © 2008 Georgia O'Keeffe Museum/Artists Rights Society (ARS), New York; Alexander Calder, *Triple Gong*, 1951. © 2008 Calder Foundation, New York/Artists Rights Society (ARS), New York; Bill Viola, *Dissolution*, 2005. © Bill Viola, image courtesy James Cohan Gallery; Bill Traylor, *Man Reaching for Bottle*, 1939–42. © Richard Huffman; William Harper, *Grand Barbarian's Trapeze and Cask*, 1998. © William Harper; Wang Jin, *Dream of China*, 2005. © Wang Jin; Seydou Keita, *Untitled (Seated Woman)*, ca. 1955. © Estate of Seydou Keita; Sue Williamson, *Better Lives I and II*, 2003. © Sue Williamson, image courtesy Axis Gallery; Yinka Shonibare, *Lady Walking a Tightrope*, 2006. © Yinka Shonibare MBE, image courtesy Stephen Friedman Gallery; El Anatsui, *Many Came Back*, 2005. © El Anatsui.

CONTRIBUTING AUTHORS

Susan H. Auth, Ph.D., former Curator of Classical Art

Lucy Brotman, former Director for Education

Ismael Calderon, Ed.D., Director of Science

Christa Clarke, Ph.D., Curator, Arts of Africa and Senior Curator, Arts of Africa and the Americas

Holly Pyne Connor, Ph.D., Curator of Nineteenth-Century American Art

Kevin Conod, Manager/Astronomer

Ulysses Grant Dietz, Curator of Decorative Arts Collection and Senior Curator

Alison Edwards, Director of Exhibition Planning and Special Projects

Ted Lind, Deputy Director for Education

Mary-Kate O'Hare, Ph.D., Associate Curator of American Art

Sule Oygur, Ph.D., Curator of Natural Science

Katherine Anne Paul, Ph.D., Curator of the Arts of Asia

William Peniston, Ph.D., Librarian

Helene P. Peters, Manager, Educational Loan Collection

Mary Sue Sweeney Price, Director

Valrae Reynolds, former Curator of the Asian Collections

Kristen Schmid, Senior Animal Keeper

Anne Spencer, former Curator of Africa, the Americas and the Pacific

Beth Venn, Curator of Modern and Contemporary Art and Senior Curator, Department of American Art

FUNDING PARTNERS

The Newark Museum is pleased to recognize these primary funding partners who have played a critical role in its successful commitment to excellence in art, science and education over the past one hundred years.

City of Newark
State of New Jersey

Louis Bamberger
Bank of America
Alice and Leonard Dreyfuss
Mr. and Mrs. Charles W. Engelhard
Essex County Board of Chosen Freeholders
Geraldine R. Dodge Foundation
Horizon Blue Cross Blue Shield of New Jersey Foundation
Institute of Museum & Library Services
Jaqua Foundation
The Kresge Foundation
The Willard T. C. Johnson Foundation, Inc.
Arlene and Leonard Lieberman

Lila Wallace–Reader's Digest Fund Museum Collections Accessibility Initiative
The Henry Luce Foundation, Inc.
Mr. and Mrs. Joseph J. Melone
National Endowment for the Arts
National Endowment for the Humanities
New Jersey State Council on the Arts/Department of State
New Jersey Cultural Trust
Prudential Financial
Lore Ross
Victoria Foundation
The Wallace Foundation
Mr. and Mrs. Earl LeRoy Wood

As of December 31, 2008